Black & White Photography Techniques

WITH ADOBE® PHOTOSHOP®

MAURICE HAMILTON

AMHERST MEDIA, INC. ■ BUFFALO, NY

DEDICATION

This book is dedicated to my parents, Margaret and Deforrest, with appreciation for their support in many ways.

ACKNOWLEDGMENTS

The author acknowledges with gratitude the contributions of the following individuals to this book: My wife, Vivien, for her encouragement, perceptive comments, and assistance. Nevada Wier, for providing an image from her unique portfolio. Editors Michelle Perkins and Barbara A. Lynch-Johnt, and publisher Craig Alesse of Amherst Media, for the editing, layout, and production of this book.

ABOUT THE AUTHOR

Maurice Hamilton is an award-winning landscape, nature, and travel photographer based in Los Altos and Groveland, California. He has traveled to many countries to explore and photograph remote and exotic locations, but he specializes in documenting the grandeur of the American West. Maurice is also the author of *The Digital Darkroom Guide with Adobe® Photoshop®* (Amherst Media, 2004) and sponsors workshops that explain the techniques presented in his books. Information on his fine-art images and workshops is available at www.hamiltonphoto.com.

Copyright © 2006 by Maurice Hamilton.
All rights reserved.
Published by:
Amherst Media®
P.O. Box 586
Buffalo, N.Y. 14226
Fax: 716-874-4508
www.AmherstMedia.com

Publisher: Craig Alesse
Senior Editor/Production Manager: Michelle Perkins
Assistant Editor: Barbara A. Lynch-Johnt

ISBN: 1-58428-173-1
Library of Congress Control Number: 2005926587
Printed in Korea.
10 9 8 7 6 5 4 3 2 1

Contents

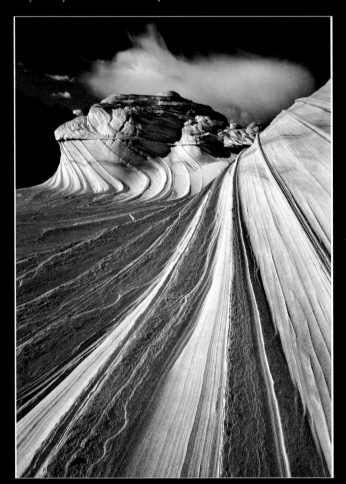

Introduction

The traditional chemical darkroom provides photographers the means to control the processing of black-and-white images. By using tools such as dodging and burning and techniques that influence the color cast of a print, photographers tap creative talents to convey the feeling of the moment when an image was captured. During this process, knowledge of darkroom chemistry is combined with the sensitivity of an artist to create a fine-art print. This print, the finale to the composition and performance of a visual symphony, represents a synthesis of the physical elements of the scene with the photographer's visualization of the final image.

With the recent advent of the digital darkroom, photographers are now able to utilize a broader range of creative techniques to produce fine-art prints. In addition to the advantages of avoiding personal and environmental exposure to toxic chemicals, the digital darkroom offers a degree of control and reproducibility not previously available. For color photographers, it provides the opportunity to exercise greater control over the creation of the print, rather than delegating it to a commercial laboratory. The digital darkroom also enables photographers to utilize and expand upon techniques derived from the chemical darkroom to create black-and-white prints from either black-and-white or color images.

The purpose of this book is to describe and illustrate techniques to create professional-quality black-and-white prints in the digital darkroom. Familiarity with Adobe Photoshop or a similar imaging program is assumed. Because Adobe Photoshop is such a powerful program, it represents the primary imaging program I use in my digital darkroom. Nonetheless, for those photographers not yet ready to commit to the full Photoshop program, Adobe Photoshop Elements and other imaging programs can be utilized to achieve similar results. The requisite background information on using these programs is available in a number of publications, including my book entitled *The Digital Darkroom Guide with Adobe Photoshop* (Amherst Media, 2004).

Basic Concepts

■ THE ZONE SYSTEM

Ansel Adams is widely recognized for his codification of the Zone System to describe the range of tonalities within an image. This system is considered to be composed of three components: visualization, exposure control, and contrast control. Visualization occurs in the mind, exposure control in the camera, and contrast control in the darkroom. Using the Zone System, Adams was able to visualize a desired final image and then expose, develop, and print the negative to achieve an appearance that captured the essence of the moment.

Through visualization, the photographer determines the desired appearance of the print even before the image has been exposed. "Visualization," writes Adams, "is a conscious process of projecting the final photographic image in the mind before taking the first steps in actually photographing the subject."[1] Those elements that will appear as shadows, midtones, and highlights are decided in advance. With this image in mind and exposure meter in hand, the photographer adjusts the camera aperture and shutter speed for the proper exposure and records the image. Within the darkroom, the photographer brings the visualized image to fruition by controlling contrast during negative development and selecting a paper with the appropriate contrast grade for printing. As summarized by Adams:

> VISUALIZATION OCCURS IN THE MIND, EXPOSURE CONTROL IN THE CAMERA, AND CONTRAST CONTROL IN THE DARKROOM.

The Zone System allows us to relate various luminances of a subject with the gray values from black to white that we visualize to represent each one in the final image. This is the basis for the visualization procedure, whether the representation is literal or a departure from reality as projected in our "mind's eye." After the creative visualization of the image, photography is a continuous chain of controls involving adjustment of camera position and other image manage-

ment considerations, evaluation of the luminances of the subject and placement of these luminances on the exposure scale of the negative, appropriate development of the negative, and the making of the print.[2]

Central to this framework is the concept that all tones from black to white can be represented as values ranging from 0 to X (Roman numerals). A middle-gray print value corresponding to the 18% gray card is assigned a value of V. An exposure reading taken from a single-luminance surface and used to produce a middle-gray print Value V is known as a Zone V exposure. This produces a negative density defined as negative density Value V. Adams differentiated between *zone,* which he used only to refer to the exposure scale, and *value,* used for the other concepts. Although the print value is fixed, the subject value it represents is not fixed. Instead, the photographer assigns the zone to the subject, regardless of its original tonality, so that the "subject luminances [are] represented *as we want them to be* by a range of gray values (or color values) in a print."[3]

With the midpoint established, Adams then defined each of the remaining zones as a one-stop exposure change from Zone V. Darker exposures yield lower zone numbers and lighter exposures higher zone numbers.

> VALUE VIII IS VERY LIGHT BUT SHOWS SLIGHT TEXTURE, AND VALUES VI AND VII SHOW THE DETAIL AND TEXTURE OF THE SUBJECT.

Value 0 is completely black, the darkest density possible with the paper used. Value I is almost full black, with very little detail. At the other extreme, Value X represents the pure white of the paper base, and Value IX is almost pure white. Intermediate values reveal a corresponding progression. On the darker side, Value II shows only a bit of texture, whereas Values III and IV clearly reveal the detail and texture of the subject. On the lighter side, Value VIII is very light but shows slight texture, and Values VI and VII show the detail and texture of the subject. Adams realized that these values were discrete points on a continuous scale, with each single value representing a range of grays.

Within the full tonal range represented by Zones 0 to X, Adams defined the dynamic range as the first useful values above Zone 0 and below Zone X, corresponding to Zones I to IX, the zones with at least a little texture or detail. The zones conveying definite texture and detail, Zones II to VIII, represent the textural range. Exposure latitude refers to the range of values that a particular film (or, by extrapolation, digital sensor) can record and is a function of both the subject luminance range and the characteristic curve of the film or sensor.

Another key element of the Zone System is the adjustment of contrast by modifying the conditions under which film is processed in the chemical darkroom. Each material has its own characteristic curve, which is modified by exposure and, traditionally, processing in the chemical darkroom to achieve the desired tonality. Modification of development, typically by

increasing or decreasing the development time, allows one to compensate for long (high-contrast) or short (low-contrast) subject luminance scales. This requires correlating the range of luminances in an image with the processing conditions so a long range can be compressed to fit the printing range and a short range extended.

The process of increasing the contrast by lengthening the developing time is known as expansion, whereas that of lowering contrast by decreasing development is termed contraction. As an example, a negative exposed to a four-zone range of subject luminances can be printed with a range of five values using expanded development. The development of such a negative, expanded by one zone, is known as N+1 development. Similarly, a negative exposed to a five-zone range of luminance values can be printed with a range of four values using contracted development, known as N-1 development. For black-and-white negatives, the primary effect of expansion or contraction is in the higher values. Thus, the highlights are modified by development and exposure, whereas the shadows are affected primarily by exposure—hence the adage in black-and-white photography to "expose for the shadows and develop for the highlights."

These principles also apply, with adjustment of scale to compensate for decreased exposure latitude, to color negative film. This is a consequence of the fact that for both black-and-white and color negative film, the low-density areas represent the shadows. In contrast, with color positive (transparency) film, the low-density areas represent the highlights. Thus, to translate this concept to positive film, the principle is modified to

THE HIGHLIGHTS SHOULD NOT BE MORE THAN ABOUT TWO TO THREE STOPS OVEREXPOSED IF THEY ARE TO HOLD DETAIL.

expose for the highlights. However, positive transparency film offers little opportunity to develop for the shadows, so detail may be lost in the shadows if they are neglected in the exposure calculation. One may, therefore, choose to overexpose the highlights slightly if needed to improve shadow detail, but this should never be so much that highlight detail is lost. In images where the desired dynamic range exceeds the exposure latitude of the film or digital sensor, it may be preferable to capture two images, one exposed for the highlights and the other exposed for the shadows, and combine them during processing in the digital darkroom.

Another important consideration in applying the Zone System to color positive film is that this film is characterized by an exposure latitude of only five to six stops, ranging from about Zone II for shadows to Zone VIII for highlights. (Review the characteristic curve for your film and/or conduct your own tests to determine its actual exposure latitude.) Accordingly, one must make appropriate adjustments to the Zone System as taught by Adams to determine proper exposure for highlights and shadows with color positive film. In practical terms, this means that when shooting with a color positive film, such as Velvia or Ektachrome, the shadows may be two to three stops below the reading from a spot meter and the highlights two to

three stops above. Consequently, the highlights should not be more than about two to three stops overexposed if they are to hold detail. Since these concepts are based upon exposing elements of a scene using a spot meter, they are not directly applicable to exposure settings determined using a camera's built-in evaluative or matrix metering system. Nonetheless, photographers should understand these basic principles.

☐ THE HISTOGRAM

The histogram is a bar graph that depicts on the y-axis the number of pixels for each tonal or color intensity value, ranging from black to white, as shown on the x-axis. By correlating the tonal values in the histogram with values in the Zone System, one can evaluate the distribution of pixels within the different zones. The histogram displays the number of pixels with tonal value 0 (Zone 0) on the left, the number of pixels with tonal value 128 (Zone V) in the middle, and the number of pixels with tonal value 255 (Zone X) on the right (fig. 1-1). By imagining the histogram divided into 11 zones, it is possible to visualize the distribution of pixels within each zone.

The relationship between zone values in the Zone System and RGB and Grayscale tonality is illustrated in figure 1-2, which shows a black-to-white wedge with tonality ranging from black (Zone 0) on the left to white (Zone X) on the right. Beneath the wedge are RGB and Grayscale values corresponding to each of these zones. Thus, Zone 0 = RGB 0, Zone I = RGB 25, Zone II = RGB 51, Zone III = RGB 76, Zone IV = RGB 102,

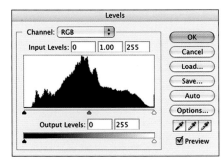

FIGURE 1-1. HISTOGRAM. The Levels dialog box depicts the number of pixels for each tonal value.

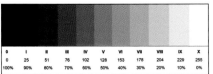

FIGURE 1-2. ZONE WEDGE. This wedge shows tones ranging from black to white with corresponding Zone System, RGB, and Grayscale values.

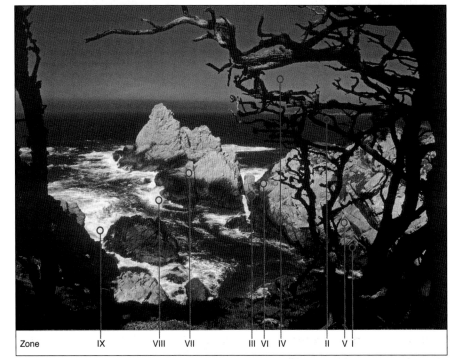

FIGURE 1-3. ZONE SYSTEM. Zones I through IX reveal at least a little texture and represent the dynamic range.

Zone V = RGB 128, Zone VI = RGB 153, Zone VII = RGB 178, Zone VIII = RGB 204, Zone IX = RGB 229, and Zone X = 255. The Grayscale values, which are expressed as the percentage of black ink, start at 100% and decrease by 10% in each successive zone. Zones I through IX are identified in the image of Rocky Point shown in figure 1-3.

The histogram can be accessed in Photoshop from the Histogram palette or the Levels dialog box. In versions of Photoshop prior to CS, the menu item Image>Histogram shows the histogram; in this view, the distribution of pixels can be displayed based upon Luminosity or the individual Red, Green, or Blue channels (for RGB images). In later versions of Photoshop, the histogram is available as a palette displaying "real-time" data. If not visible on the desktop, the Histogram palette can be opened via the menu item Window>Histogram.

By default, the Histogram palette opens in Compact View, which displays the histogram without other options. In Expanded View (selected by clicking the arrowhead in the upper-right corner of the palette), the Histogram palette offers a choice of display channels and image statistics. For RGB or CMYK images, selecting RGB or CMYK in the Channel pop-up menu displays a composite histogram of all the channels (fig. 1-4a). Selecting an individual color channel reveals the histogram for that color (fig. 1-4b). Choosing Luminosity shows a histogram of the luminance or intensity values of the composite channel (fig. 1-4c). Though similar to the RGB or CMYK histogram, Luminosity applies a different weight to each color channel to approximate the luminance of the composite channel. The Colors channel shows a composite histogram of each channel in the color of that channel—this is the option I typically select (fig. 1-4d).

Tonal information can be viewed for the Entire Image, the Selected Layer, or the Adjustment Composite. If Adjustment Composite is chosen, selecting an adjustment layer shows the histogram for that layer, including all the layers below. Information about a particular pixel level or value can be viewed by placing the cursor over the histogram;

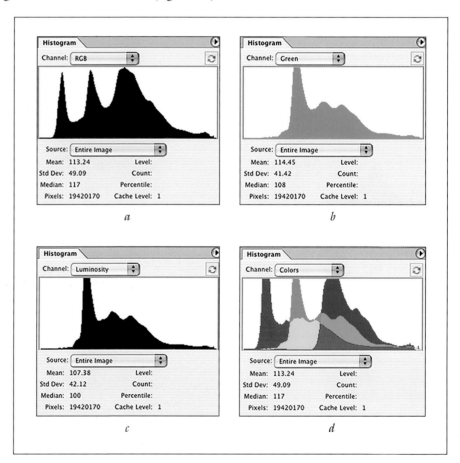

FIGURES 1-4A, B, C, AND D. HISTOGRAM PALETTE. Channel options for viewing the histogram include (a) all channels, (b) individual color channels, (c) luminosity, and (d) colors, a composite showing each channel in color.

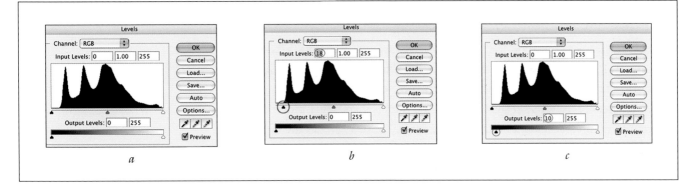

a *b* *c*

FIGURES 1-5A, B, AND C. LEVELS. (a) Levels displays the image histogram and permits adjustment of shadows and highlights. (b) The black Input Levels slider has been moved to the right, increasing image contrast. (c) The black Output Levels slider has been moved to the right, decreasing image contrast.

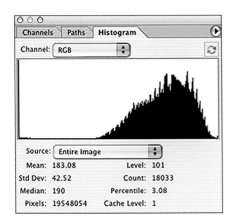

FIGURE 1-6. HIGH-KEY HISTOGRAM. This histogram shows the characteristic distribution of pixels for a high-key image, with relatively few pixels in the midtones and few, if any, pixels in the shadows.

available data include the pixel count at that level and the percentile of pixels at or below that level (from 0% at the far left to 100% at the far right). If the Histogram palette displays a yellow warning icon (an exclamation mark in a triangle), the data displayed are being read from the document's cache rather than its current state. To refresh the histogram display, click the warning icon or double-click within the histogram.

The histogram can also be viewed in the Levels dialog box (Image>Adjustments>Levels or Layer>New Adjustment Layer>Levels), which includes a horizontal gradient bar at the bottom of the window that provides a visual display of the tones corresponding to the levels in the histogram (fig. 1-5a). Unlike the Histogram palette, the Levels dialog box permits one to modify image tonality. By moving the black and white sliders at the bottom of the histogram, the contrast of the image can be increased; this is analogous to expansion in the chemical darkroom (fig. 1-5b). Similarly, by moving the black and white sliders along the gradient bar at the bottom of the dialog box, the contrast of the image can be decreased; this is analogous to contraction in the traditional darkroom (fig. 1-5c).

Analyzing the range of tones within an image allows one to assess the tonal balance and degree of contrast in the image and to ascertain that detail in the highlights and shadows has not been lost. A preponderance of pixels toward the left side of the histogram indicates that information is primarily in the shadows (a low-key image), whereas a high concentration of pixels toward the right side of the histogram indicates that image detail is principally in the highlights (a high-key image; fig. 1-6). An image with a full tonal range reveals pixels distributed across the entire range from shadows to highlights. When the number of pixels abruptly terminates in the shadows or highlights, detail has most likely been lost in those respective areas, and the shadows or highlights are said to be clipped. Not surprisingly, such loss of data should be avoided.

These considerations of tonal distribution apply regardless of the mode of image pixel capture, whether from a digital camera or film scanner. When using a digital camera, the histogram should be analyzed to confirm that the exposure yields an appropriate distribution of pixels without clipping. Similarly, when scanning film, adjustments should be made using the scanner software to provide an optimal histogram prior to the final scan.

☐ CURVES

The Curves dialog box in Photoshop provides a graphical representation of image tonality for each of the 256 intensity levels (in 8-bits/channel images), with output values on the y-axis displayed as a function of input values on the x-axis (fig. 1-7). For color images, Curves displays shadows on the left and highlights on the right: at the lower-left corner is the graphical representation of black as 0, and at the upper-right corner is the representation of white as 255. With no modification to the diagonal line in Curves, the input and output values are equal. Adjustments that move any part of the curve above this baseline increase the pixel values for that portion of the image, resulting in a lighter image, whereas adjustments that lower the curve below the baseline darken the image. As a corollary, increasing the slope of the curve increases the contrast of the affected pixels, whereas decreasing the slope decreases the contrast. This is easily understood if one considers that with an increased slope, the tonal range of the output values for a given range of input values is increased, whereas the opposite occurs with a decreased slope. Increasing the slope of the curve also increases the saturation of the image. For Grayscale images, Curves displays percentages from 0 to 100%, with highlights (0) on the left and shadows (100%) on the right. With this display, moving the curve below the baseline lightens the image, while moving the curve above the baseline darkens the image. To reverse the display of shadows and highlights and switch the input/output values between intensity level and percentage, click the double arrow below the curve.

As with the histogram, the representation in Curves of black and white as pixel intensity values 0 and 255, respectively, corresponds to their values in the Zone System as 0 and X. If one views Curves displayed on a 10 x 10 grid (Option/Alt+click on the grid to toggle between views), each division on the grid corresponds to one zone. Thus, if the Curves grid is considered as a graph with origin at the lower-left corner and x and y values ranging from 0 to 10, the zone of an image point can be determined by its coordinates on the graph. For example, if Command/Control+clicking on a point in the image places a point on the graph at x = 4, y = 4, this point corresponds to Zone IV. If this point is dragged upward to x = 4, y = 5, its output has been changed to Zone V (fig. 1-8). With this technique, one can measure and modify the zone corresponding to any area of the image.

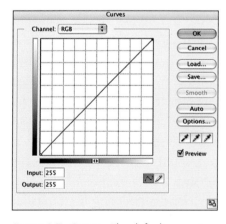

FIGURE 1-7. CURVES. The default curve is a diagonal line that reflects equal input and output values. Each division on the grid corresponds to one zone, ranging from 0 on the left to X on the right.

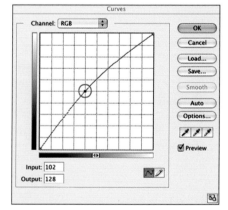

FIGURE 1-8. MODIFIED CURVE. Pulling the curve upward as indicated lightens midtone values and, in this image, corresponds to changing the output value of Zone IV to Zone V.

However, abrupt changes in the slope of the curve should be avoided, and a positive (upward) slope should be maintained, unless the purpose is to produce solarization or other special effects.

This correlation between Curves and the Zone System provides a framework for understanding the concepts of the Zone System and applying them in the digital darkroom. Photographers accustomed to working with the Zone System can perhaps more easily visualize the effect of Curves adjustments on image tonality. Conversely, photographers more adept at using Curves in the darkroom than the Zone System in the field may be able to translate their digital darkroom knowledge into more sophisticated image exposure.

1. Ansel Adams, *The Negative, The Ansel Adams Photography Series,* no. 2 (Little, Brown and Company, 2000).
2. *Ibid.*
3. *Ibid.*

The Digital Darkroom

The basic tools of the digital darkroom, in addition to a PC or Mac computer with adequate speed and memory, are the image processing software—Adobe Photoshop in most professional environments—plus a calibrated monitor, digital image source (scanner or digital camera), and printer. Other accessories, including a second monitor and a graphics tablet, can expedite the workflow.

■ ADOBE PHOTOSHOP

One can create professional prints using any of several software programs. I think most photographers agree that Adobe Photoshop is the most powerful of the available options. For the most part, the techniques described in this book can be accomplished using Photoshop 6 or higher. Nonetheless, I would encourage photographers with serious digital darkroom aspirations to upgrade to the latest version of Photoshop in order to enjoy the full range of features. To achieve the best results with Photoshop, Preferences (Command/Control+K) and Color Settings (Photoshop> Color Settings or Edit>Color Settings) must be individualized for your desired output. My preferred Color Settings are shown in figure 2-1.

For nonprofessionals, Photoshop Elements offers admission to the digital darkroom for about $90, less than one-sixth the price of the full version. However, to take advantage of certain powerful Photoshop features, such as Curves, one needs the full version of Photoshop. Students should be aware of a significant discount available toward the purchase of the full version.

■ CALIBRATED MONITOR

A crucial component of the digital darkroom is a color management workflow that includes a calibrated and profiled monitor, which renders the appearance of an image on the screen as close as possible to its appearance in print, allowing for the inherent differences between images viewed with

FIGURE 2-1. Adobe PHOTOSHOP COLOR SETTINGS. Choose Adobe RGB (1998) or Ekta Space PS 5, J. Holmes as the RGB Working Space. For Conversion Options, select Adobe (ACE) with Perceptual or Relative Colorimetric Intent with Black Point Compensation.

transmissive vs. reflective light. While it may be possible to tweak the monitor to match the output from a given printer, I recommend that the monitor be calibrated and profiled using ICC profiles, which allow the file to be printed accurately by any profiled printer, including a commercial printer. For the novice, monitor calibration using the Adobe Gamma feature included with Photoshop may seem appealing, as it is relatively simple and does not require the purchase of any additional software or hardware. Unfortunately, the results obtained with this software-only approach are not generally satisfactory for professional-quality work. I believe that a software–hardware monitor calibration system represents a key element in a managed color workflow. The good news is that it need not cost a whole lot. Several excellent products are available that include a colorimeter with software for calibrating and profiling a CRT and/or LCD monitor for around $300 or less. These include the updated Eye-One Display from Gretag-Macbeth, ColorEyes Display from Integrated Color Corporation, Spyder2PRO Studio from ColorVision, and the Monaco OPTIXXR or Monaco OPTIX Precision Calibrator. Products and prices change frequently, so the reader is advised to review the products and occasional discounts on calibration products from a company such as Chromix.

> I BELIEVE THAT A SOFTWARE–HARDWARE MONITOR CALIBRATION SYSTEM REPRESENTS A KEY ELEMENT IN A MANAGED COLOR WORKFLOW.

☐ DIGITAL IMAGE SOURCE

Potential sources of input for the digital darkroom include flatbed and desktop film scanners, commercial scanners, and digital cameras. Regardless of the source, one must have an optimal image to achieve an optimal print. While it is possible to overcome some shortcomings of a flawed image in the digital darkroom, devoting the effort necessary to achieve proper composition and exposure at the time of image capture is much more efficient than attempting to compensate for poor technique in the darkroom. Even the finest orchestra cannot overcome the limitations of a poorly written score.

Film Scanner. For most serious photographers using film, a desktop film scanner is an important part of the digital darkroom. For less than $700, one can purchase a 35mm slide scanner such as the Nikon Coolscan V ED with resolution 4000 dpi or the Konica Minolta DiMAGE Scan Elite 5400 with resolution 5400 dpi. The more robust Nikon Coolscan 5000 ED (also 4000 dpi) sells for around $1100. Similarly, desktop film scanners are available for medium-format film. For example, the Nikon Coolscan 9000 ED scanner, which sells for about $2000, can scan mounted or unmounted 35mm slides in addition to film up to 6 x 7 cm at resolution 4000 dpi.

Flatbed Scanner. Color prints and transparencies as well as black-and-white prints and negatives can be scanned using a flatbed scanner. A flatbed

scanner can also be used as a "digital camera" by carefully positioning subjects such as flowers directly on the scanner glass. Amazingly, a flatbed scanner costing less than $500 can create an image file from a large-format transparency of quality approaching (but not quite reaching) that from a $30,000 drum scanner. If one is scanning 35mm transparencies, the quality of the image file from a flatbed scanner with transparency adapter may suffice for Web-based images, but not for large prints. In this latter instance, one should use a desktop film scanner or commercial laboratory.

Commercial Scanner. The "gold standard" for scanning images is generally considered to be a drum scanner, which yields images with higher resolution and broader dynamic range than desktop film scanners. Due to their cost, drum scanners are found almost exclusively in commercial

AS A GENERAL RULE, NO SHARPENING SHOULD BE APPLIED DURING THE PERFORMANCE OF A DRUM SCAN.

labs. Drum scans of 35mm transparencies are typically made at resolution 5000 ppi, yielding an image file slightly greater than 100MB with an 8-bit scan and double that size with a 16-bit scan. Scans at lower resolution may be made with larger positive transparencies or negatives, depending upon the number of pixels needed to create the largest print desired from that image file. The goal should be to create a master scan that is suitable for all anticipated future needs. As a general rule, no sharpening should be applied during the performance of a drum scan.

A less expensive commercial option is a Kodak Photo or Pro Photo CD scan. Photo CD scans are inexpensive but yield a relatively small print at optimal resolution. Pro Photo CD scans add an additional image resolution of 4096 x 6144 pixels to those included with the Photo CD, producing an image file size of 73.7MB at 8-bits/channel and twice that size at 16-bits/channel. The quality of Pro Photo CD scans may approach that of drum scans at less than half the cost.

Digital Camera. Although a detailed discussion of digital cameras is beyond the scope of this book, several factors need to be considered in selecting a camera. One should know the number of megapixels necessary for the desired image output size. Also important is the quality of the digital sensor, which determines tonal range, color gamut, and noise in the image file. With 6–8MP (or higher) cameras such as Nikon or Canon SLR models, many photographers are able to create excellent 16 x 24-inch prints. Depending upon the sharpness of the image, the viewing distance, and the megapixels, these cameras may also produce high-quality 20 x 30-inch prints. Noise typically limits the ability of small, compact cameras to produce good-quality prints larger than 8 x 12 inches or perhaps 12 x 18 inches.

Another factor to consider is the size of the CCD or CMOS imaging chip. If the size of the chip is the same as film, a lens of a given focal length will create an image with the rated lens magnification. However, most digital cameras contain imaging chips smaller than film, resulting in apparent

image magnification by factors ranging from 1.3 to 1.6 times the rated focal length of the lens. This may be advantageous when using a telephoto lens, but it makes it difficult to obtain a truly wide-angle image except with a lens specifically designed for a digital camera.

☐ PRINTERS, PAPERS, AND PROFILES

Inkjet Printers. In the past, a major limitation of inkjet printers was their inability to produce archival prints due to their use of dye-based inks. Although dye-based printers are known for the richness of their colors, these inks have not been archival. Nonetheless, dye-based printers, such as the Epson Stylus Photo 1280, are excellent for making non-archival prints and proofs for images to be printed by commercial printers.

This limitation was overcome with the development of pigment-based inks for inkjet printers. Using UltraChrome pigment-based inks, Epson Stylus Photo 2200 and Epson Stylus Pro 4000, 7600, and 9600 printers are able to create archival prints with rich colors that approach those of dye-based prints, truly transforming the capabilities of the digital darkroom. In addition to five color inks, UltraChrome inks include a "light black" ink together with Photo Black and Matte Black inks (the choice of black ink depends upon the type of paper), enhancing the quality of black-and-white prints from inkjet printers. Many photographers incorporate the Epson 2200 printer into their digital darkroom to produce UltraChrome prints up to 13 x 19 inches, and, for larger UltraChrome prints, some photographers add an Epson 4000, 7600, or 9600 printer. Prints from the Epson 9600 printer are also available from commercial laboratories, such as Calypso Imaging and West Coast Imaging (table 2-1).

	LIGHTJET	CHROMIRA	EPSON 7600/7800 & 9600/9800	PIEZOGRAPHY
INKS	No inks. Lasers expose Type-C photographic paper.	No inks. LEDs expose Type-C photographic paper.	UltraChrome pigment/dye-based inks.	PiezoTone carbon-based inks.
PAPERS	• Fuji Crystal Archive Matte • Fuji Crystal Archive Gloss • Fujiflex Crystal Archive Supergloss	• Fuji Crystal Archive Matte • Fuji Crystal Archive Gloss • Fujiflex Crystal Archive Supergloss	• Epson Premium Glossy Photo Paper • Epson Premium Luster Photo Paper • Epson Premium SemiMatte Photo Paper • Hahnemuhle Photo Rag 308 • Somerset Photo Enhanced Velvet • Concorde Rag	• Hahnemuhle Photo Rag 308 • Somerset Photo Enhanced Velvet • Concorde Rag

TABLE 2-1. PRINTERS AND PAPERS. This chart lists selected paper types available from commercial labs.

The degree of black-and-white image control has been enhanced with the updated UltraChrome K3 ink technology introduced by Epson in the Stylus Photo R2400 and Stylus Pro 4800, 7800, and 9800 printers. This new ink set, which adds a third black ink, "light-light black," to the colors in the original UltraChrome ink set, is designed to create neutral and toned black-and-white prints without color casts. Changes in the ink, including higher-density pigments and a new pigment encapsulation chemistry, produce prints with better color fidelity, reduced metamerism, and greater scratch resistance compared to the original UltraChrome inks.

Another development in inkjet printing has been the introduction by Hewlett-Packard of printers that use six-color, dye-based inks that produce archival prints when used in conjunction with certain HP papers. One of these printers is the Hewlett-Packard Designjet 130 printer, a desktop model with a cassette that accepts paper up to 18 x 24 inches and a manual rear-feed path that accommodates paper up to 24 x 64 inches. This printer features a high D-max and creates prints with colors that appear very rich. The Designjet 130 lists for $1300, less than half the cost of the Epson 7600. Smaller siblings, the Designjet 30 and Designjet 90, produce prints up to 13 x 19 inches and 18 x 24 inches, respectively.

SOME COMMERCIAL LABORATORIES OFFER LARGER PIEZOGRAPHY PRINTS FROM EPSON 7600 AND 9600 PRINTERS.

Piezography. An alternative inkjet technique, known as Cone Piezography, uses Epson inkjet printers but replaces the standard ink cartridges with a custom quadtone inkset based on carbon black pigment. These inks, known as PiezoTones, are available in Warm Neutral, Selenium Tone, Carbon Sepia, and Cool Neutral gray sets. One of these gray tones is combined with one of two black position inks, Museum Black (for maximal longevity), or Portfolio Black (for greater optical density). Specialized software drivers control the placement of the black inks by the Epson nozzles. This system can be utilized with certain Epson desktop printers, including the Epson 1280. A starter kit including one gray tone and one black ink with PiezographyBW ICC media profiles for the Epson 1280 sells for about $300. A Piezography system with custom printer profiles is also available.

Some commercial laboratories offer larger Piezography prints from Epson 7600 and 9600 printers. Sundance Warm Neutral Piezography prints in sizes up to 24 inches and Selenium Tone Piezography prints in sizes up to 44 inches are available from West Coast Imaging. Sundance Warm Neutral ink creates tones similar to platinum prints, whereas the Selenium Tone with Museum Black ink is characterized by a cool color designed to match the color of traditional selenium-toned silver gelatin prints. Papers available for these prints include Hahnemühle Photo Rag 308, Somerset Photo Enhanced Velvet, and Concorde Rag.

Papers. Using different types of papers allows one to produce black-and-white prints with a fine-art appearance. For the Epson 2200, Epson Velvet Fine Art Paper is a 100% cotton rag, acid-free paper with a Wilhelm Im-

aging Research permanence rating of 58 years (when framed under glass) that produces very nice fine-art prints. Epson does not recommend this paper for the Epson 1280 printer, although I have heard of photographers using it; remember that the dye-based inks used by the Epson 1280 are not archival. Epson Enhanced Matte paper offers a flat matte surface with an estimated print permanence of 64 years with Epson 7600/9600 printers (not rated for the Epson 2200 printer, although it uses the same inks). Papers rated for the Epson 2200 include Epson Watercolor Paper (Radiant White), with a permanence rating of 92 years, and Epson Premium Luster Photo Paper, with estimated print permanence of 71 years. For black-and-white prints created using the full-color UltraChrome inkset, the permanence rating with these papers is even longer, generally greater than 100 years. Other companies also manufacture papers that can be used with Epson and other printers, although Wilhelm Imaging Research print permanence ratings are not necessarily available.

Similar papers are available for Epson 4000, 7600, and 9600 printers. Media available from commercial laboratories include Epson Premium Luster Photo Paper, Epson Premium Semi-Matte Photo Paper, Somerset Photo Enhanced Velvet, Hahnemühle Photo Rag 308, and Concorde Rag. Not all laboratories offer prints on all of these papers, so you may need to check with more than one lab to obtain a print on a particular paper. HP photographic papers available for the Designjet 30 and 130 printers include Photo Matte, Photo Gloss, and Photo Satin. Prints made with these printers using HP No. 85 ink cartridges and HP Premium Plus papers (Photo Gloss and Photo Satin) have a projected permanence rating of 82 years when displayed under glass.

Printer Profiles. To produce a print that matches the appearance of the image on the monitor, the printer must be properly profiled. Every printer manufacturer supplies printer profiles that are typically included as part of the software used to install the printer. Updated profiles may be available from the company's website. These profiles are based upon general characteristics of the printer model, not upon a specific printer. Consequently, these printer profiles may not produce optimal results, in which case a custom printer profile is needed. For persons wishing to profile a printer in addition to a monitor, Gretag-Macbeth offers Eye-One Photo (for RGB printers) for about $1,500. Gretag-Macbeth's Eye-One Publish profiles a scanner in addition to printer and monitor for about $2,700. A less expensive option is MonacoEZcolor with the Monaco OPTIX colorimeter, which profiles monitor, scanner, and printer for around $350. Custom printer profiles can also be ordered from www.ProfileCity.com (now part of www.Chromix.com) for about $100 each. This is most useful if one prints on only one or two different types of paper, as a separate profile is necessary for each printer–paper combination.

TO PRODUCE A PRINT THAT MATCHES THE APPEARANCE OF THE IMAGE ON THE MONITOR, THE PRINTER MUST BE PROPERLY PROFILED.

Raster Image Processor (RIP) Software. The longevity of UltraChrome prints would be even longer were it not for the yellow ink, which reportedly has only about half of the lightfastness of the yellow pigment in Epson's earlier Archival inkset. Accordingly, by eliminating the UltraChrome yellow ink when printing black-and-white prints, one can produce an image with even greater longevity. RIP software products, such as ImagePrint (www.colorbytesoftware.com) and ColorBurst (www.colorburstrip.com), control the individual ink channels and can eliminate the yellow pigment from prints. For monochromatic prints, these products can use only Black Photo or Black Matte and Light Black inks, or they can print with all colors except yellow, dark cyan, and dark magenta, the colors primarily responsible for metamerism. RIP software usually includes excellent printer profiles. These products start at around $500 for desktop printers.

Commercial Photographic Printers. Commercial laboratories, such as Calypso Imaging and West Coast Imaging, use LightJet or Chromira printers to produce black-and-white images on Fuji Crystal Archive Paper exposed using red, green, and blue lasers (LightJet) or LEDs (Chromira). This paper is processed using RA4 chemistry and is available with matte, gloss, or supergloss finish. For black-and-white prints, matte would be the usual choice. As with any process using color to produce grayscale images, it may be difficult to achieve a completely neutral black-and-white print. Nonetheless, very nice results are possible, especially with images characterized by a slight tonal shift.

☐ THE IMAGE FILE

If the original image is a color negative or transparency slide, it should be scanned as a color image (not grayscale) into an RGB color space with a relatively wide gamut, such as Adobe RGB (1998) or Ekta Space PS 5, J. Holmes (fig. 2-2). This applies to color images that will be printed in black-and-white as well as to images that will be printed in color.

When scanning film, the techniques used to improve the scan will vary depending upon the scanner software options. In my digital darkroom, I scan 35mm and 6 x 7 cm color transparencies with the Nikon Super Coolscan 8000 ED using Nikon Scan software. This software offers adjustments of tonality and color, sharpening, and other settings that are so important for obtaining an optimal scan that I am going to describe them in detail. Similar adjustments are possible with software that accompanies scanners from other manufacturers and with third-party software, such as LaserSoft SilverFast Ai scan.

The scanner can be operated within Photoshop, in which case the scanned image automatically opens in Photoshop, or as an independent program, in which case the image must be saved to the hard drive or other storage device for later editing in Photoshop. Although it is more convenient to scan within Photoshop and save the image as a Photoshop PSD file, I find that Nikon Scan processes scans more quickly when it is the only

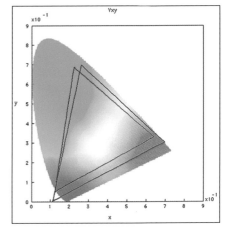

FIGURE 2-2. ADOBE RGB (1998) VS. EKTA SPACE. Ekta Space (blue) has a somewhat larger gamut than Adobe RGB (red), but either color space is able to capture most of the information in E6 film.

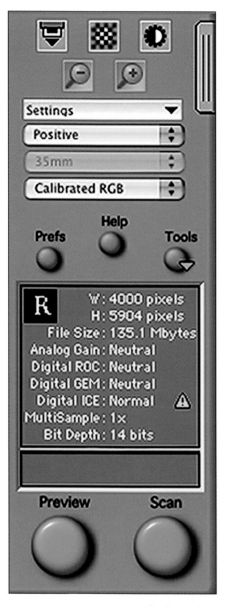

FIGURE 2-3. NIKON SCAN CONSOLE. Preview the scanner settings summarized in the Console window before scanning.

application running. With large image files, the difference can be significant. Test your own system to determine which method works better for you.

To scan within Photoshop, go to File>Import>Nikon Scan (or the name of your software). Otherwise, directly open Nikon Scan (or your scanning program); in order to maximize the memory available for the scanner, do not open Photoshop. The Nikon Scan Console, the primary control panel for the scanner, is shown in figure 2-3. When first using Nikon Scan, the preferences should be specified. Click on the Prefs button to open the Preferences dialog box. For Color Management, select Use Nikon Color Management System. For Monitor, choose the custom monitor profile created by your monitor calibration and profiling system. Remember to update this profile setting after creating a new monitor profile. Under RGB, select Adobe RGB (1998), regardless of whether you have a Mac or PC. Ignore the advice about using a color space with gamma 1.8 if you are using a Mac.

The Nikon Scan Settings menu allows particular scanner settings to be saved for later use. Click on the menu bar to specify the type of film being scanned. For all color transparency film other than Kodachrome, choose Positive. Due to higher density and greater contrast than equivalent E-6 film, such as Velvia or Ektachrome, Kodachrome film is listed as a separate item. Choose Neg (Color) for dye-based (chromogenic) black-and-white film (C-41 process). Choose Neg (Mono) for silver halide-based black-and-white film. Even though the film is black and white, the red, green, and blue LEDs perform the scan. Confirm the size of the film (e.g., 35mm) and set the color space to Calibrated RGB rather than Grayscale or CMYK.

Now press the Preview button to view a small-resolution scan, which can be enlarged on the monitor by dragging the lower-right corner of the preview window outward. Drag the "marching ants" around the preview image to select the area to be scanned. Next, view the Nikon Scan tool palettes, which offer a multitude of possible settings. Correct the orientation of the image, if needed, using the Layout Tools. Set the image file size in the Crop palette to the maximum available resolution of 4000 pixels/inch with a scale of 100% in order to create the largest file size possible for the master image. If you are scanning only for the Web or for a small print size and are confident that you will not want a large print, you can choose a lower resolution.

Nikon Scan includes several technologies to improve the quality of scans. For me, Digital ICE (Image Correction & Enhancement) is the most important. By scanning the film with an infrared beam, Digital ICE eliminates most dust and scratches from the image. I believe this process softens the scan slightly, but usually not significantly, especially if one applies a bit of sharpening during scanning. Digital ICE can be a tremendous time-saver, and I routinely use it in Normal mode when scanning E-6 film. Unfortunately, due to the nature of the Kodachrome dye and film develop-

ment process, earlier versions of Digital ICE may misinterpret Kodachrome image details as defects, leading to anomalies in the scan. Digital ICE Professional, integrated into Nikon Super Coolscan 5000 ED and 9000 ED scanners, is reportedly compatible with Kodachrome film. Digital ICE can be used with black-and-white chromogenic film (C-41 process), but not traditional silver-halide black-and-white film. This is because Digital ICE perceives silver-halide salts as imperfections and tries to correct them, resulting in a posterized or embossed image.

Nikon Scan also includes Digital ROC (Reconstruction of Color) to restore color to faded images and Digital GEM (Grain Equalization and Management) to reduce image grain. In the case of an image with significant grain in a region such as the sky, one can scan the image once with and again without Digital GEM, then combine these images in Photoshop to minimize the objectionable grain without softening other areas. Beginning with the Nikon Super Coolscan 5000 ED and 9000 ED scanners, Nikon Scan also incorporates Digital DEE (Dynamic Exposure Extender) to reveal details in shadows and highlights.

Sharpening can be applied to all or selected colors during the scan. Choose the colors (all, red, green, blue, cyan, magenta, yellow) to be sharpened from the pop-up menu near the upper right of the Unsharp Mask palette. If more than one color has been chosen, use the arrows along the left side of the color list to arrange them in order of priority. Then select values for Intensity, Halo Width, and Threshold. The Intensity settings range from 0 to 100%, roughly corresponding to Amount values of 0 to 500% in Photoshop's Unsharp Mask filter. The Halo Width sets the distance over which the sharpening effect extends, with values from 1 to 100%. The Threshold specifies the difference between tonal values necessary for sharpening to be applied. As in Photoshop, a value of 0 causes all tonal differences to be sharpened. I usually apply a small amount of sharpening during Nikon scans, although some photographers prefer not to sharpen during scanning. Perform tests with different sharpening parameters to determine the optimal settings for your images.

THE THRESHOLD SPECIFIES THE DIFFERENCE BETWEEN TONAL VALUES NECESSARY FOR SHARPENING TO BE APPLIED.

Scanner Bit Depth is specified in the Scanner Extras palette. Now that Photoshop provides extensive support for 16-bits/channel images, I scan images intended for output as fine-art prints with the higher-bit depth (14-bits or 16-bits/channel, depending upon the scanner), rather than 8-bits/channel. Of course, this doubles the file size, which can become significant, especially with medium-format images. This palette also contains controls for Multi-Sample Scanning. The CCD sensors in scanners tend to produce noise in dark shadows. This noise can be minimized by sampling each pixel multiple times, then averaging the resultant values. The options for Multi-Sample Scanning are 1, 2, 4, 8, and 16 samples, which increase the scanning time proportionately. The results may justify the extra time

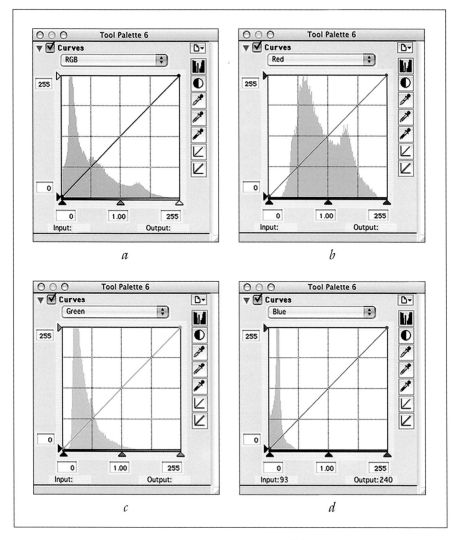

FIGURE 2-4A, B, C, AND D. NIKON SCAN CURVES PALETTE. (a) Composite histogram shows clipped shadows after preview scan. (b) Red-channel histogram shows ideal distribution. (c) Green-channel histogram is skewed toward the shadows but does not show clipping. (d) Blue-channel histogram is skewed to the left and shows clipping in the shadows.

when scanning high-dynamic-range transparencies. Another option, the CCD Scan Mode, can be set to Super Fine Scan to reduce banding that may appear in high-density scans. With this setting, the scanner uses only one of the three CCD sensor rows, so the scans take three times as long.

Curves, LCH, Color Balance, and Analog Gain control the tonality and color of the scanned image. These tools provide a histogram that shows the distribution of pixels from the shadows on the left to the highlights on the right. Ensuring that the scanned image contains an appropriately broad dynamic range with pixels distributed across this range, while maintaining detail in the shadows and highlights, is the goal for most scans. The characteristics of an ideal histogram, discussed in the previous chapter, likewise apply to the image scan.

The Curves palette depicts a histogram of the image with controls that combine the features of Levels and Curves in Photoshop (fig. 2-4). The composite RGB image or the individual color channels can be adjusted separately. These controls allow one to modify image tonality and color and are analogous to those in Photoshop. Other controls on the right side of this palette include an Auto Levels control (black/white circle icon) and eyedroppers to set the white, gray, and black points in the image. Below the eyedroppers are buttons to reset the currently selected curve to neutral and to reset all channels.

The Color Balance palette provides sliders that increase or decrease Brightness, Contrast, Red, Green, and Blue, which may be useful to remove a color cast. If the color cast is in one of the secondary colors (cyan, magenta, or yellow), it can be reduced by increasing the complementary color (red, green, or blue, respectively). When correcting a color cast based upon the appearance of an image in Nikon Scan, confirm that the correct monitor profile is specified in the Nikon Scan preferences.

Analog Gain controls the exposure of the film to the red, green, and blue LED light sources during the scan, permitting an increase or decrease in exposure to each individual color by up to 2 EV. These settings can be used to adjust the overall tonality of the scan and to correct suboptimal exposure of the individual colors, which can be assessed by evaluating the histogram for each color. The Analog Gain panel is depicted in figure 2-5, which shows an example in which the blue LED is set to expose the film by an additional 2EV. This adjustment was performed due to clipping of the blue shadows in the histogram shown in figure 2-4d. Clicking on the Redraw button at the lower right of the Analog Gain panel after increasing the exposure to blue shifted the blue pixels toward the right so the shadow values are no longer clipped (fig. 2-6). Because of the ability to independently control the color sources, exposure to one color can be increased at the same time exposure to another color is decreased. Analog Gain can also compensate for consistent over- or underexposure or color casts in scanned images.

The principle of optimizing the histogram also applies when a digital camera is used as the source of the image file. If the histogram displayed on your digital camera is shifted far to the left, brighten the exposure by increasing the exposure time or the lens aperture. If the highlights are clipped, reduce the exposure time or lens aperture to decrease the exposure. When the dynamic range of the scene exceeds that of your camera's sensor, adjust the exposure to create an image as bright as possible without losing detail in the highlights.

Each digital camera manufacturer provides proprietary software that can be used to import images from the camera into the computer for subsequent processing in Photoshop. In addition, the Adobe Photoshop Camera Raw plug-in is now integrated into Photoshop. Camera Raw can open raw

FIGURE 2-5. NIKON SCAN ANALOG GAIN PANEL. The blue channel is set for an exposure of 2.00, corresponding to +2 EV above normal exposure.

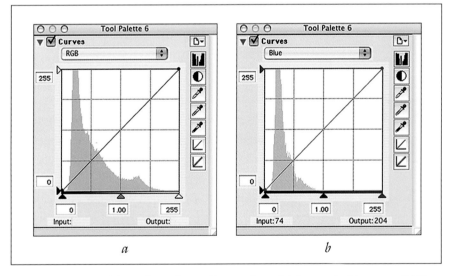

FIGURES 2-6A AND B. NIKON SCAN CURVES PALETTE, RESET. (a) Composite histogram. (b) Blue-channel histogram. After increasing exposure in the blue channel, the histograms no longer show clipping in the shadows.

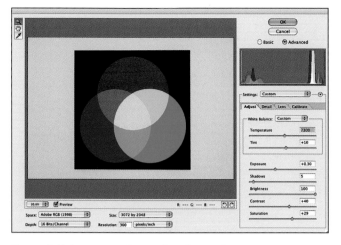

FIGURE 2-7. PHOTOSHOP CAMERA RAW DIALOG BOX.

file formats from many digital cameras, and the list of supported cameras is regularly updated. Although the software from the camera manufacturer may provide somewhat more detail in the shadows and highlights, many users prefer Camera Raw due to its convenience and generally excellent results. Camera Raw displays a histogram that shows a composite display of each color channel and permits a number of adjustments to images before they are opened in Photoshop (fig. 2-7). These adjustments include setting the white point; modifying image exposure, shadows, brightness, contrast, saturation, colors; and correcting for chromatic aberration or vignetting introduced by the camera lens. The ability to perform these adjustments on raw digital image files before they are opened for processing in Photoshop represents another reason to "go digital."

The Master Image

The file obtained after exposure in the scanner or digital camera—the digital negative—is analogous to a traditional negative that will be processed in the chemical darkroom. Although electrons replace chemicals in digital imaging, the principles of the Zone System still form the basis for tonal adjustments. This chapter describes the workflow I apply to the digital negative to create the master image file. Most of these techniques apply to both color and black-and-white film.

■ ANALYZE THE HISTOGRAM

Review the Histogram palette or the histogram in Levels to confirm that you are starting with a well-exposed digital file and that the shadows and highlights are not clipped. If the histogram reveals significant problems with a scanned image, consider rescanning the image and modifying the exposure as described in the previous chapter. If this is not feasible, try applying a drastic tone correction using a tool such as the Shadow/Highlight command (described in this chapter) to determine if the image is usable before proceeding.

> REVIEW THE HISTOGRAM PALETTE OR THE HISTOGRAM IN LEVELS TO CONFIRM THAT YOU ARE STARTING WITH A WELL-EXPOSED DIGITAL FILE…

■ CROP AND ROTATE THE IMAGE

A scanned image will generally be surrounded by a black border. To eliminate this border, fit the image on the screen (Command/Control+0 [zero]), then select the Crop tool (press C) and drag to outline the image. Now view the image at 100% magnification (Command/Control+Option/Alt+0 [zero]) and adjust the crop margins, zooming back out to the fit-on-screen view if needed. Rotate the bounding box by placing the cursor outside the box and dragging in the appropriate direction to align its borders with the image margins. To delete the pixels outside the bounding box, press Enter or click on the check mark at the right end of the Options bar. If you are not certain that you want to permanently delete these pixels,

click on the button to Hide rather than Delete the Cropped Area in the Options bar. (Hiding the cropped area is not an option when the image consists of only the Background layer.) Hidden pixels can be retrieved later by selecting Image>Reveal All.

☐ REMOVE DUST AND SCRATCHES

Next, remove dust, scratches, and other imperfections. Click on the Create a New Layer icon at the bottom of the Layers palette and name this layer "Dust & Scratches." Then choose the Clone Stamp tool (S, Shift+S) and, from the Options bar, select the Use All Layers box. For some defects, the Healing Brush tool (J, Shift+J) may facilitate the repair. Like the Clone Stamp, the Healing Brush can now be applied to an empty layer with the Use All Layers option selected. Viewing the image at 100% (Command/Control+Option/Alt+0 [zero]), use the Clone Stamp and/or Healing Brush to remove any dust and defects. Start with a 35- to 45-pixel soft brush and adjust the diameter as appropriate for the specific defects. Press the left (open) bracket key ("[") to make the brush smaller or the right (close) bracket key ("]") to make the brush larger. Press Shift+[to make the brush softer or Shift+] to make the brush harder.

With this approach, cloning and healing do not alter the original image pixels. Since these modified pixels are on a separate layer, undesirable cloning or healing effects can be deleted using the Eraser tool (E, Shift+E), and the Clone Stamp or Healing Brush can then be reapplied. Placing the cloned or healed pixels on a separate layer also makes it possible to modify how they blend with the underlying image by changing the opacity or blending mode of the layer.

If the image is covered with multiple imperfections or specks of dust, they can often be eliminated using the Dust & Scratches filter (Filter>Noise>Dust & Scratches). Since this filter modifies image pixels, apply it to a duplicate image layer (Command/Control+J). First,

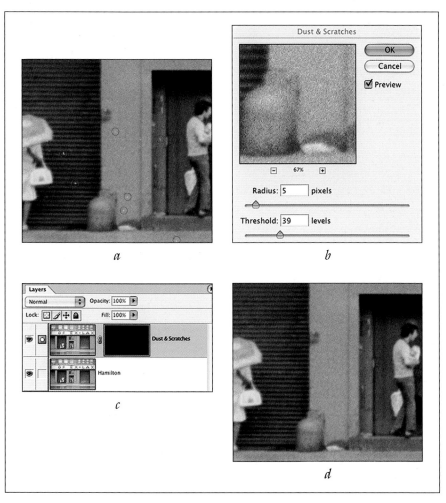

FIGURES 3-1A, B, C, AND D. DUST & SCRATCHES FILTER. (a) Image displays multiple defects, some of which are circled. (b) Dust & Scratches dialog box shows radius and threshold settings used to eliminate defects from the image. (c) The Layers palette shows duplicate image layer to which Dust & Scratches filter was applied, hidden by layer mask. (d) Image after Dust & Scratches filter was applied as described in text.

drag the Threshold and Radius sliders all the way to the left. Then, with the image at 100% magnification, slowly move the Radius slider to the right and stop at the smallest pixel value that eliminates the defects. To reduce the blurring introduced by this adjustment, slowly move the Threshold slider to the right until the defects start to reappear, then move the slider back to the left just a bit until the defects are no longer visible (fig. 3-1).

If the image sharpness seems acceptable, you can stop working on the Dust & Scratches layer and perform any necessary cloning or healing on a new layer above this one. However, if you desire optimal results, add a layer mask that hides this layer by pressing Option/Alt and clicking on the Add a Mask icon at the bottom of the Layers palette. With this mask selected, choose a soft-edged white brush about the size of the defects to be removed and scroll through the image, painting over the defects to reveal the blurring applied by the Dust & Scratches filter. An alternative approach utilizes the History Brush. Go to the History palette and highlight the state that precedes the application of the Dust & Scratches filter, then click on the empty box at the left side of the Dust & Scratches state to specify it as the source for the History Brush (fig. 3-2). Now select the History Brush tool (Y, Shift+Y) and paint over defects in the image to eliminate them. This should yield the same appearance as the previous technique. Larger defects may require correction through subsequent application of the Cloning Stamp or Healing Brush tools on a new layer above this one.

☐ SET WHITE AND BLACK POINTS

My initial tonal adjustments set the shadows and highlights to modify the dynamic range as appropriate for the image. Most, but not all, images will have a black point and a white point. These adjustments can be performed using either Levels or Curves.

Levels. Adjustments using Levels allow one to correct the tonal range of an image by modifying the intensity levels of the image's highlights, midtones, and shadows. The black-to-white bar at the bottom of the Levels dialog box provides a visual representation of the tones affected by these adjustments. To add a Levels adjustment layer, click on the half-black/half-white circle icon at the base of the Layers palette and choose Levels from the pop-up menu (fig. 3-3). For versions of Photoshop prior to CS, adjustment layers cannot be used with 16-bits/channel files. If using high-bit files with an earlier version of Photoshop, apply tonal adjustments to the image (a copy of the original image file should be used) prior to conversion to an 8-bits/channel file (Image>Mode>8 Bits/Channel).

The Levels dialog box provides two different techniques for specifying the dynamic range of the image. Perhaps the more intuitive approach is to set the white and black points by moving the corresponding sliders. Moving the white Input Levels slider to the left redefines all values to the right of the slider as white, stretching the histogram to the right so this point is relocated to pixel value 255. To set the white point, move the white

FIGURE 3-2. BACK TO THE FUTURE. The History Brush applies pixels from the Dust & Scratches layer to the image state before the filter was applied.

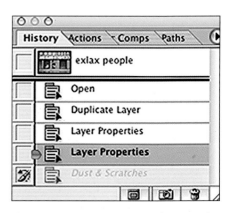

FIGURE 3-3. LAYERS PALETTE ICONS. At the bottom of the Layers palette are icons to add a Layer Style, add a Layer Mask, add a Layer Set, add an Adjustment or Fill Layer (menu displayed), add a Layer, and delete a layer.

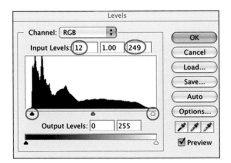

FIGURE 3-4. LEVELS. The white Input Levels slider has been moved to set the white point to 249, and the black Input Levels slider has been moved to set the black point to 12.

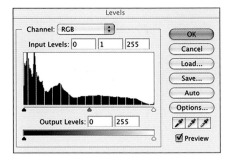

FIGURE 3-5. HIGHLIGHTS. The white areas represent the highlights of the image, which can be viewed from Levels by pressing the Option/Alt key as the white slider is moved to the left or from a Threshold layer by moving the slider to the left from Threshold level 255 until white pixels appear.

FIGURE 3-6. GAPS IN HISTOGRAM. After expanding the histogram by moving the black slider, small gaps appeared in the histogram of this 8-bits/channel image, indicating lack of pixels at those values. These gaps are small and should not cause any problems.

slider to the left until it reaches the area on the right side of the histogram where significant pixels appear (fig. 3-4). To determine which pixels are affected by moving the white point to a given value, hold down the Option/Alt key while moving the slider to that position: pixels appearing against the black background will be white (255) in at least one color channel (fig. 3-5). If areas that should retain detail appear, decrease the amount by which the white slider is moved.

Similarly, moving the black Input Levels slider to the right redefines black as all values to the left of the slider, stretching the histogram to the left so this point is shifted to pixel value 0. To set the black point, move the black slider to the right until it reaches the area on the left side of the histogram where significant pixels appear. To visualize which pixels are affected by moving the black point to a given value, hold down the Option/Alt key while moving the slider to that position: pixels appearing against the white background will be black (0) in at least one color channel. With these adjustments, the white and black points have been set, and the dynamic range of the image has been defined.

After adjusting the dynamic range, gaps may appear scattered across the histogram, indicative of few or no pixels at those tones (fig. 3-6). These gaps result from "stretching" the histogram without sufficient tonal values—fewer than the potential 256 tonal values per channel in an 8-bits/channel file—to provide smooth gradations. If the gaps are wider than about three tonal values, the image may become posterized, displaying bands of tone or color resulting from coarse transitions between tonal values. This problem is virtually nonexistent with high-bit files, which allow up to 16-bits of information per channel, providing a total of 65,536 potential tonal values per channel. With so many possible tonal values in high-bit images, tonality can usually be adjusted without introducing gaps into the histogram. Since Photoshop now supports adjustment layers with 16-bit files, I recommend that high-bit image files be maintained as far into the workflow as possible.

Another method for setting the white and black points uses the white and black point eyedroppers in the Levels dialog box (fig. 3-7). These same eyedroppers can also be accessed from the Curves dialog box. Using this approach, the initial step is to define the RGB pixel values for the white and black points. Double-click on the white or black point eyedropper to reveal the Color Picker, then select the desired values for that point. For example, as depicted in figures 3-8a and 3-8b, one might choose a white point with values of 0/0/96 in the HSB (hue, saturation, brightness) model (corresponding to approximately RGB 245/245/245) and a black point of 0/0/4 in HSB (approximately RGB 10/10/10). Specifying equal values for each of the RGB components, 0 for hue and saturation in HSB mode, or 0 for the a and b channels in Lab mode, sets these tones to neutral values. Consequently, setting the dynamic range using these eyedroppers adjusts image color in addition to tonality.

The next step is to select the points in the image to which these values will be assigned, i.e., the points that will be defined as the white and black points. One approach is to identify the lightest area in the image by moving the white Input Levels slider to the left with the Option/Alt key depressed until significant pixels representing the highlights appear against a black background. Then determine the darkest area in the image by moving

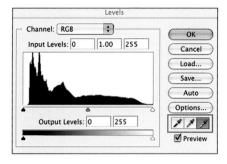

FIGURE 3-7. EYEDROPPERS. The location of the eyedroppers in the Levels dialog box is outlined, showing the black point, gray point, and white point eyedroppers.

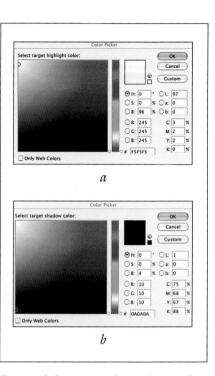

FIGURES 3-8A AND B. COLOR PICKER. Settings for the (a) white point and (b) black point can be accessed by double-clicking on the eyedroppers in the Levels dialog box.

the black Input Levels slider to the right while pressing the Option/Alt key until pixels representing the shadows appear against a white background. Remember the values of those points. Alternatively, the shadows and highlights can be determined by clicking the half-black/half-white circle icon at the base of the Layers palette and selecting Threshold from the new adjustment layer menu. The default position of the Threshold slider below the histogram is 128. Move the slider all the way to the right, then slowly back to the left until white pixels representing the lightest area are revealed against a black background (fig. 3-9). Remember the value for this Threshold Level. To mark the precise position of this highlight, press the Shift key and click on the image to place a Color Sampler at that location. Now move the Threshold slider all the way to the left and then back to the right to identify the darkest area, which appears as black pixels against a white background. Remember the Threshold Level value of this shadow point and place a Color Sampler to mark its position.

The final step in this sequence is to apply the white and black point values previously specified using the eyedroppers to the highlight and shadow points identified in the image. Select the white eyedropper from the Levels dialog box and click on the image highlight to set the white point. If this does not yield the desired result, try clicking on other bright areas in the image until you find the one that produces the best appearance. Next, select the black eyedropper and click on the image shadow point to set the black point. Again, it may be necessary to click on several dark areas of the image to achieve the optimal result.

Curves. Curves adjustments represent a much more versatile means of setting the white and black points and allow one to do everything Levels can do and more. Use a temporary Levels or Threshold adjustment layer to determine the threshold values for the highlights and shadows as described above. Now use a Curves adjustment layer to set the highlight and shadow values. Slide the top-right end of the curve (representing 255) to the left to the desired highlight value, then slide the bottom-left end (representing 0) to the right to the desired shadow value (fig. 3-10). This is similar to mov-

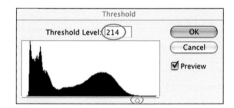

FIGURES 3-9A AND B. THRESHOLD. The dialog box indicates that the Threshold Level for the highlights in the image is 214. This corresponds to the image highlights visualized as white pixels in figure 3-5.

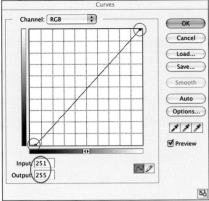

FIGURE 3-10. CURVES. The highlights and shadows have been reset by moving the right end of the curve to the left and the left end of the curve to the right.

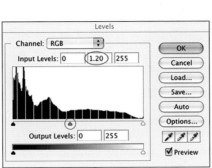

FIGURE 3-11. LEVELS GAMMA ADJUSTMENT. The midtone slider has been moved to the left to gamma value 1.20, lightening the midtones.

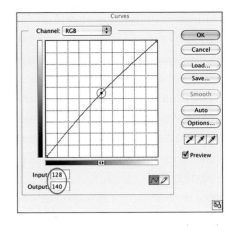

FIGURE 3-12. CURVES ADJUSTMENT. The midpoint of the curve has been moved up from Zone V to about Zone V½ (value 140), lightening the midtones. This is similar to moving the midtone slider in Levels.

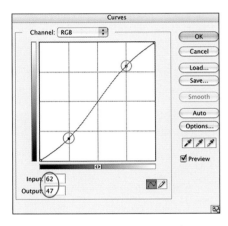

FIGURE 3-13. S-SHAPED CURVE. The one-quarter and three-quarter points have been moved to increase the contrast.

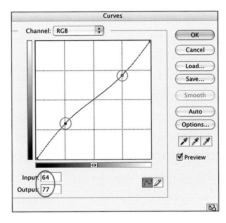

FIGURE 3-14. REVERSE S-SHAPED CURVE. This curve decreases contrast in the midtones but increases contrast in the highlights and shadows, where the slope of the curve is increased.

ing the white and black sliders in Levels and likewise establishes the dynamic range. As an alternative, the white point and black point eye-droppers can be accessed from the Curves dialog box.

☐ ADJUST BRIGHTNESS

After setting the highlights and shadows, I adjust the midtones. Using Levels, this can be accomplished by moving the midtone gamma slider to the left to lighten the image or to the right to darken it (fig. 3-11). With Curves, moving the midpoint of the curve up or down produces an overall lightening or darkening of the image, similar to that achieved with the midtone slider in Levels (fig. 3-12). However, using Curves permits more precise and sophisticated adjustments than Levels.

With a Curves adjustment, image contrast can be modified without changing the dynamic range by applying an S-shaped curve to increase brightness in the one-quarter tones and decrease brightness in the three-quarter tones (fig. 3-13). Or, contrast in the midtones can be decreased without altering the dynamic range by applying a "reverse S" curve between the white and black points (fig. 3-14). Clicking on the curve on either side of an area to be modified fixes ("locks down") those points so they do not move when other portions of the curve are adjusted—this per-

mits more precise adjustment of selected tonal ranges. Changing the blending mode of a Curves adjustment layer from Normal to Luminosity (selected from the pop-up menu at the upper left of the Layers palette) eliminates any undesirable color shift that may be introduced by a Curves adjustment.

Although I usually adjust brightness using Levels or Curves, brightness can also be modified using layer blending modes, which determine how the active layer interacts with the layer below (fig. 3-15). In Normal mode, the layer does not blend with other layers. However, when an image is duplicated to a layer with the blending mode set to Multiply, the image darkens as if two negatives or transparencies were superimposed, similar to being underexposed by about two stops. When the layer containing the duplicate image is set to Screen blending mode, the image lightens as if two transparencies were projected on top of each other, similar to being overexposed by about two stops. Setting the blending mode of the duplicate image layer to Soft Light or Overlay increases image contrast.

Applying blending modes to a duplicate image layer provides a simple means to modify the tonality or contrast of an image, but it results in a file size twice as large due to the duplicate image layer. Fortunately, there is an alternative. Adding a Curves or Levels adjustment layer with a given blending mode above the background image layer yields the same effect as if the blending mode had been applied to a duplicate image layer—but without an increase in file size. If the darkening or lightening from the blending mode layer is too great, it can be reduced by decreasing the opacity of the layer. If a stronger correction is needed, the adjustment layer can be duplicated to double the effect. Even finer control can be achieved by modifying the settings in a Levels blending mode layer or the shape of the curve in a Curves blending mode layer.

☐ CORRECT THE COLOR

Now that the tonality of the image has been adjusted, the next step for color images is to optimize the colors. This is true even when the goal is a black-and-white print. Adjustments that enhance differences between colors may yield better separation of tones in the black-and-white image. In addition, it is more efficient to incorporate tonal and color adjustments into the workflow before committing the image to black-and-white if there is a chance that a color print may be desired in the future.

Levels or Curves. To set an object in the image to a neutral tone, select the gray eyedropper located between the black and white eyedroppers in the Levels or Curves dialog box, then click on the desired area in the image. This adjusts the midpoints of the red, green, and blue channels to remove any color cast but, unlike the white and black eyedroppers, does not change the brightness of the image. Neutralizing image tones will not always be advantageous. For example, scenes photographed in early morning or late afternoon light are typically characterized by a warmth that would be eliminated by using the gray eyedropper. If clicking on one point

FIGURE 3-15. BLENDING MODES. The menu to specify the blending mode for a layer is located at the upper left of the Layers palette.

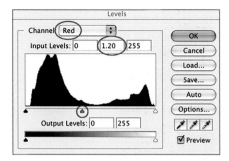

FIGURE 3-16. LEVELS ADJUSTMENT LAYER, RED CHANNEL. Moving the midtone slider for the red channel to the left lightens reds in the image.

FIGURE 3-17. COLOR BALANCE. The color balance in the midtones has been shifted toward red and away from cyan while preserving luminosity.

FIGURE 3-18. SELECTIVE COLOR. Reds have been darkened in this example by increasing the amount of black.

in the image does not produce the desired result, click on other points that appear as if they should be neutral until you achieve the correct color balance. To maintain maximal flexibility with this adjustment, you may want to apply it using a separate Levels or Curves adjustment layer so the opacity can be decreased, if necessary, to blend this adjustment with the original image.

Levels or Curves adjustment layers can also be used to adjust color balance by applying changes to individual color channels. To use this technique with Levels, select a color channel from the Channel pop-up menu at the top of the Levels dialog box, then adjust the midtone slider and also the shadow and highlight sliders if needed. As an example, if the Red channel is selected in Levels, move the midtone slider to the left to lighten the reds, or move it to the right to darken them (fig. 3-16). Similar adjustments can be performed on the blue and green channels. Likewise, with the Red channel selected in Curves, drag the curve upward and to the left to lighten the reds or drag it downward and to the right to darken them. Applying adjustments to the individual color channels in Curves provides maximal control over the brightness and contrast of each color.

Color Balance. The balance between the primary colors—red, green, and blue—and their complementary colors—cyan, magenta, and yellow—can be altered using a Color Balance adjustment layer. This is useful to eliminate an unwanted color cast. To add a Color Balance adjustment layer, click on the half-black/half-white circle icon at the bottom of the Layers palette and select Color Balance from the menu. Check the Preserve Luminosity box to maintain tonal balance in the image. Select the tonal range (Shadows, Midtones, or Highlights) to which the adjustment will be applied, then move the sliders to achieve the desired balance between colors (fig. 3-17).

Selective Color. The component colors of reds, yellows, greens, cyans, blues, magentas, whites, neutrals, and blacks can be modified using a Selective Color adjustment layer. For each color, the percentage of cyan, magenta, yellow, and black is specified (fig. 3-18). A negative percentage value increases the percentage of the complementary color. Undesired colors in the highlights can be adjusted using the Whites selection, and neutral areas can be corrected with the Neutrals option. Each color can also be lightened or darkened by decreasing or increasing the amount of black.

Hue/Saturation. By using a Hue/Saturation adjustment layer, the global color of an image can be adjusted by moving the Hue slider. This is not an adjustment I make often, but occasionally it can be helpful to improve a color cast. This adjustment can also be applied to individual colors (reds, yellows, greens, cyans, blues, and magentas) or to a color range selected using the eyedroppers at the bottom of the dialog box. These eyedroppers become available when a color range other than Master (representing all colors) has been selected.

The Hue/Saturation dialog box also allows one to alter the saturation of an image (fig. 3-19a). This is frequently necessary after scanning to restore the brilliance of the original image. Boosting image saturation not only enhances the colors but may also make them easier to separate when the image is converted to black and white. Move the Saturation slider to the right to around 10 to 15%, then adjust that setting based upon image appearance. To change the saturation of a specific color, select the color range or click on the eyedroppers in the dialog box to select the color directly from the image (fig. 3-19b).

FIGURES 3-19A AND B. HUE/SATURATION. (a) The image saturation has been increased by 15%. (b) The saturation of the reds has been increased an additional 15%.

☐ ADJUST PROBLEM AREAS

At this point, the shadow and highlight values have been set, overall brightness and contrast adjusted, and color corrected. Most images will need additional adjustment of tones within specific areas, frequently in highlights or shadows. This section describes techniques to adjust problem areas.

Selections. The basic selection tools, accessed from the upper part of the Toolbox, are the Marquee, Lasso, and Magic Wand (fig. 3-20). Marquee tool selections are based upon geometric shapes, whereas Lasso tool selections are drawn freehand, in linear segments, or along boundaries. In contrast, the Magic Wand creates selections based upon the color of the pixels sampled. Selections can also be made using the Color Range command and by using techniques that evaluate image luminosity. After the selection is created, it will be loaded as a mask for an adjustment layer to modulate changes in tonality that target specific areas in the image.

Magic Wand Selection. The range of colors targeted by the Magic Wand is determined by the Tolerance setting, which varies from 0 to 255. Low values limit the colors selected to those similar to the color clicked. Higher values include pixels with a greater color range. To limit the selection to adjacent areas using the same colors, select Contiguous. Check the Use All Layers box to select colors using data from all visible layers, not only the active layer. Before sampling with the Magic Wand, select the Eyedropper tool (I, Shift+I) to set the sample size used by the Magic Wand. In the Options bar, choose either 3 by 3 Average or 5 by 5 Average, not Point Sample. Return to the Magic Wand tool and click in the image on the color

FIGURE 3-20. TOOLBOX. The Marquee, Lasso, and Magic Wand selection tools are located at the top of the Toolbox.

you want to select. This selection can be refined by clicking on other areas to add to or subtract from the selection by choosing the appropriate keyboard shortcut or icon from the Options bar.

Creating a selection with the Magic Wand may be facilitated by making the selection from the color channel where the area of interest is most clearly delineated or by temporarily adding a Levels, Curves, or Hue/Saturation adjustment layer to accentuate differences within the image. The Magic Wand tool is useful for selecting areas with relatively uniform tone and color, such as a clear blue sky, and for refining a selection created with another tool, such as the Rectangular Marquee. The Magic Wand can also be used to select an object with an intricate shape, especially when it is surrounded by a region with little variation in color. To accomplish this, click outside the object to create a selection that excludes the object, then inverse this selection (Select>Inverse) to select the object. Alternatively, make a loose selection around the object with the Marquee or Lasso tool, then return to the Magic Wand and press Option/Alt while clicking around the object to subtract the extraneous elements from the selection.

Color Range Selection. The Color Range command creates selections based upon colors sampled with the Color Range Eyedropper, specific colors, highlights, midtones, or shadows (fig. 3-21). The dialog box provides the option to view either the selection or the image. To access the Color Range command, choose Select>Color Range from the menu bar. Select Sampled Colors in the Color Range dialog box to create a selection by clicking with the eyedropper over areas in the preview box or, with greater precision, in the image itself. The range of colors selected is determined by the Fuzziness setting: higher settings include more colors than lower ones. The selection can be increased by choosing the middle eyedropper in the dialog box (the one with the "+" sign) and clicking on additional areas of the selection or image or by pressing the Shift key while clicking with the eyedropper. In contrast, choosing the eyedropper on the right (the one with the "–" sign) and clicking on the selection or image, or pressing Option/Alt while clicking with the eyedropper, subtracts areas from the selection.

Many users do not realize that this tool can also be used to make a selection based upon highlights or shadows. If an image has shadow areas lacking detail, one can select Shadows and use this selection as the basis for lightening these regions by adding a Levels or Curves adjustment layer while this selection is active. If the highlights are too bright, one can similarly make a selection based on highlights and add a Levels or Curves adjustment layer to darken those areas. Although Color Range does not offer controls to vary the pixels selected as shadows or highlights, one can select the opposite tonal range and then check the Invert box. Thus, as an alternative to selecting shadows, one can select highlights, then choose the Invert option in the dialog box; this indirect approach includes more midtones than making a direct selection.

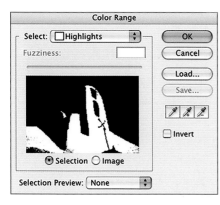

FIGURE 3-21. COLOR RANGE. The Color Range selection in this figure is based upon the highlights.

Threshold Selection. Another method for selecting shadows and highlights utilizes the Threshold command, which sets all colors in an image to black or white depending upon their tonality compared to the Threshold value. All pixels darker than the Threshold Level are set to black, and all pixels lighter than the Threshold Level are set to white. To use this technique, add a Threshold adjustment layer by clicking on the half-black/half-white circle icon at the bottom of the Layers palette and selecting Threshold from the menu. The image will appear black and white, with all pixel values less than 128 represented by black and all values greater than 128 by white. Now move the Threshold slider to the right or left until the desired shadow or highlight area appears as black or white (figs. 3-22a, 3-22b). Click OK. To create a selection of

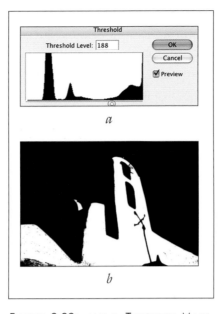

FIGURES 3-22A AND B. THRESHOLD MASK, MYCONOS. (a) The Threshold Level has been set to 188 by moving the slider under the histogram until the desired image effect was achieved. (b) The Threshold adjustment has demarcated the image highlights from the shadows, rendering a stark black-and-white image that can be used as a mask.

highlights or shadows from these pixels, choose the Magic Wand tool (uncheck the Contiguous option) or Color Range command and click on the area to be selected.

Luminosity/Density Selection. One of the easiest methods for adjusting highlights and shadows utilizes a luminosity or density selection applied as a mask. This represents a very powerful and versatile tool and is one of my preferred methods. To select the highlights, create a luminosity mask by pressing the keyboard shortcut Command/Control+Option/Alt+~ [tilde] (or Command/Control plus click on the RGB channel in the Channels palette). This creates a selection based upon the luminosity of the image, with the lightest areas being most strongly selected. At times, it may be preferable to make a luminosity mask based upon a single color channel rather than the entire image. Press Command/Control and click on that channel to load its luminosity as a selection. To adjust the shadows, press Command/Control and click on the RGB or individual color channel to load a luminosity selection, then inverse the selection (Select>Inverse) to select the darker pixels.

Press Q to enter Quick Mask mode and view the luminosity or inverted luminosity selection as a mask. To make it easier to differentiate the selected from the masked areas, double-click on the Quick Mask mode icon

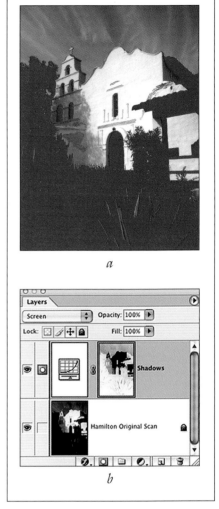

FIGURES 3-23A AND B. INVERSED LUMINOSITY SELECTION, MISSION SAN DIEGO DE ALCALA. (a) The inversed luminosity selection is displayed as a mask with shadows in red. (b) Adding a Curves adjustment layer with the inversed luminosity selection active adds it as a mask for the adjustment layer.

near the bottom of the Toolbox to open the Quick Mask Options dialog box. Set Color to Selected Areas and Opacity to 100%, then click OK. To enhance the edges of the mask, press Command/Control+L to open the Levels dialog box and move the Input Levels shadow and highlight sliders inward to increase the contrast between the selected and masked portions of the mask. If the goal is to lighten the shadows using an inverted luminosity mask, for example, move the sliders so the shadows are the color of the mask (red by default) and the mask color is eliminated from the highlights (fig. 3-23a). Press Q again to exit Quick Mask mode and return to the selection.

Levels or Curves Adjustment Layer with Masking. After selecting the problem area with any of the selection techniques described, create a new Levels or Curves adjustment layer by clicking on the half-black/half-white icon at the bottom of the Layers palette and choosing Levels or Curves from the menu. The active selection will form the basis for the mask associated with the new adjustment layer, as shown for an inverse luminosity mask in figure 3-23b. Since the mask limits changes to the area previously selected, modifying contrast or tonality will only affect the selected area. To visualize the mask as a color overlay on the image, press the backward slash ("\") key. The mask can be refined using any of the painting tools. Select the Brush tool (B, Shift+B) and paint on the mask with white over additional areas to be included in the selection or with black over areas to be excluded. Press the "\" key again to hide the mask.

To darken the selected area in the image, double-click on the Levels or Curves adjustment layer thumbnail and move the midtone slider to the right in the Levels layer or pull the curve downward in the Curves layer. An alternative method is to change the blending mode of the Levels or Curves layer from Normal to Multiply. If the selection was based on the highlights in the image, this will darken the highlights without changing the lower midtones or shadows. To lighten the selected area, move the midtone slider to the left in the Levels layer, pull the curve upward in the Curves layer, or change the blending mode of the Levels or Curves layer from Normal to Screen. If the selection was derived from the shadows, this will lighten the shadows without altering the upper midtones or highlights. If more adjustment is necessary, duplicate the adjustment layer to apply the correction again. To optimize control over the tonality of the highlights and shadows, one adjustment layer can be added for the highlights and another for the shadows.

In general, the selections produced using these tools should be blended into the surrounding image. Apply a Gaussian blur (Filter>Blur>Gaussian Blur) to the mask, selecting a radius of at least 3 to 5 pixels (fig. 3-24). For drastic changes in tonality, larger radius values will usually be necessary. View the effect upon your image as you adjust the radius for the blur.

Contrast Mask. Contrast masks utilize a negative image to decrease the dynamic range of an image with excessive contrast. In the chemical dark-

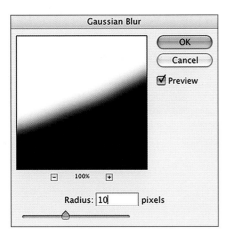

FIGURE 3-24. GAUSSIAN BLUR. The radius has been set to 10, and the blur along an edge is previewed at 100% magnification.

room, contrast masks can be used to decrease contrast in Type R (direct positive) or Ilfochrome (formerly Cibachrome) color prints, in addition to black-and-white prints. The process is straightforward. A grayscale, slightly blurred negative of an original image (an unsharp mask) is created and aligned with the positive image. Then photographic paper is exposed by shining light through the combined negative and positive images, which tones down the highlights and opens up the shadows, thereby decreasing the contrast. In addition, superimposing a slightly blurred negative image over the original image makes the image appear sharper.

In the digital darkroom, the process is the same, but much easier to implement. The simplest way to create a digital contrast mask is to make a copy of the original image layer (Command/Control+J), desaturate the new layer (Image>Adjustments>Desaturate, or Shift+Command/Control+U), and invert the layer (Command/Control+I). Increase the contrast in the mask by applying a Levels adjustment (Command/Control+L) and moving the black and white Input Levels sliders toward the center. Such a contrast mask, seen prior to blurring, is illustrated in figure 3-25. Now apply a Gaussian blur (Filter>Blur>Gaussian Blur) to the mask, starting with a Radius of 3 to 5 pixels and increasing as needed to optimize the image. From the pop-up menu at the upper left of the Layers palette, change the blending mode of the new layer to Overlay, which lightens the dark areas and darkens the light areas. This effect will usually make the image look unnatural at full layer opacity. Decrease the opacity of the Overlay layer, starting at about 10 to 15% and increasing if needed, depending upon the image and the desired effect (fig. 3-26). The contrast mask correction can be limited to specific problem areas by pressing Option/Alt and clicking the Add a Mask icon at the bottom of the Layers palette to add a mask that hides the effect of the layer. Select a medium-soft brush (B, Shift+B) and paint in white on the layer mask to apply the contrast mask to selected areas. Other blending modes, including Soft Light, Color Burn, and Normal, can also be used with this technique.

Shadow/Highlight Adjustment. The Shadow/Highlight adjustment (Image>Adjustments>Shadow/Highlight), introduced with Photoshop CS, is designed to lighten the shadows without lightening the highlights and to darken the highlights without darkening the shadows (fig. 3-27). Thus, its intent is to automate corrections to shadows and highlights. This tool is so helpful that it represents my preferred method of correcting shadows and highlights. Because this command must be applied directly to image pixels, a duplicate image layer (Command/Control+J) should be created for this adjustment. If the adjustment is being made only to shadows or highlights, a selection specific for that tonal range can be copied to a new layer (Command/Control+J after making the selection) and the Shadow/Highlight command applied to that layer.

The Shadow/Highlight dialog box, pictured in figure 3-28, appears when the Show More Options box is checked and contains separate sec-

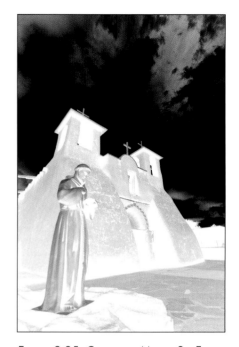

FIGURE 3-25. CONTRAST MASK, ST. FRANCIS, TAOS. A Contrast mask, not yet blurred, was formed by desaturating and inverting the image with enhancement of shadows and highlights by applying a Levels adjustment to increase contrast.

FIGURE 3-26. LAYERS PALETTE, CONTRAST MASK. The Layers palette shows the Contrast Mask, now blurred, above the image and a merged image layer above the mask.

FIGURE 3-27. IMAGE ADJUSTMENTS MENU. The location of the Shadow/Highlight command is illustrated. It is not available as an adjustment layer but must be applied directly to image pixels.

FIGURE 3-28. SHADOW/HIGHLIGHT. The default dialog box settings are shown for the Shadow/Highlight adjustment.

tions to adjust shadows and highlights. The Shadows section provides options for lightening the darkest colors, whereas the Highlights section provides parameters to darken the lightest colors. Both the Shadow and Highlight sliders include Amount, Tonal Width, and Radius. The Amount slider specifies the magnitude of the change. The default Amount in the Shadows section is 50%, which I find is too high for most of my corrections—I typically use a value of 10 to 30%. On the other hand, I may use higher settings than the default values for the Tonal Width and Radius. Tonal Width controls the range of tones modified within the shadows or highlights. When lightening shadows using the Shadows Tonal Width slider, smaller values focus on the darkest tones, whereas larger values expand the effect to include the midtones. Similarly, low values for the Highlights Tonal Width limit the adjustment to the brightest tones, and higher values include more midtones. Radius specifies the area analyzed to determine whether a given pixel is in the shadows or highlights. A larger radius results in smoother transitions between the adjusted and unadjusted areas. If the radius is too large, the adjustment may affect the entire image rather than primarily the shadows or highlights. An unnatural glow or halos may appear along dark-to-light edges if the Amount or Tonal Width is set too high or the Radius too low for an image.

> AN UNNATURAL GLOW OR HALOS MAY APPEAR ALONG DARK-TO-LIGHT EDGES IF THE AMOUNT OR TONAL WIDTH IS SET TOO HIGH OR THE RADIUS TOO LOW. . . .

Because Shadow/Highlight adjustments typically decrease image saturation, the dialog box includes a Color Correction slider. This correction only applies to the areas of the image changed by the Shadow/Highlight

a b

adjustment. The default value of 20% often works reasonably well, but I usually move the slider to determine the optimal adjustment. For grayscale images, the Color Correction adjustment is replaced with a Brightness control. Another slider controls Midtone Contrast. By default, the Midtone Contrast setting is 0, but changing this value may improve the image. Move the slider to the right to increase contrast or to the left to decrease it. An example of the results obtained after applying a Shadow/Highlight adjustment to calla lilies is shown in figure 3-29. For this modest enhancement of the shadows, I entered values of Amount 20%, Tonal Width 70%, and Radius 50%. This lightened the leaves in a way that seemed natural, while maintaining the tonality of the flowers.

Dodge and Burn. As in the chemical darkroom, dodging and burning are usually necessary to emphasize elements in an image. Several methods can be used, depending upon personal preference and the magnitude of the correction.

Curves Adjustment. To dodge or burn using Curves, create a Curves adjustment layer by clicking on the half-black/half-white circle icon at the bottom of the Layers palette. Pull the upper-right end of the curve to the left until the image appears as light as or lighter than you would want any part of it (fig. 3-30). Click OK. Then, with the Curves layer highlighted, press Command/Control+I to fill the layer mask with black and hide the effect of this layer. Lighten selected areas of the image by painting with white on the black layer mask using a medium-soft brush (B, Shift+B). By varying the opacity of the brush, you can apply more or less lightening to the image. Similarly, areas of the image can be darkened by adding a Curves adjustment layer and pulling the upper-right end of the curve down so the image is as dark as or darker than you would want any part of it. By applying the same principle of hiding the Curves layer mask and then painting on it with white, areas of the image can be selectively darkened.

FIGURES 3-29A AND B. SHADOW/HIGHLIGHT ADJUSTMENT, CALLA LILIES. (a) Pre–Shadow/Highlight adjustment. (b) Post–Shadow/Highlight adjustment. See text.

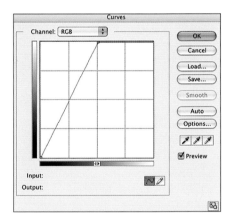

FIGURE 3-30. DODGE CURVES ADJUSTMENT. A drastic Curves adjustment serves as the basis for dodging the image.

Blending Mode Layer. To apply subtle dodging or burning to areas in the image, I often use a blending mode layer at the top of the layers stack. Select Layer>New>Layer from the menu, or press Option/Alt and click on the Create a New Layer icon at the bottom of the Layers palette, then name the new layer "Dodge & Burn." Change the blending mode of the layer from Normal to Soft Light or Overlay and fill the layer with Soft-Light- or Overlay-Neutral color (50% gray). Keep the Opacity of the layer at 100%. Now select the Brush tool (B, Shift+B) and decrease its opacity setting in the Options bar to 10–15%. Painting an area with white or any tone lighter than neutral gray will lighten the image, whereas painting an area with black or any tone darker than neutral gray will darken the image. Because of the low opacity of the Brush tool, the change produced by a given brush stroke should be subtle. Releasing the mouse button and painting over the same area again will produce a cumulative effect. To remove burning or dodging effects, use the Eraser tool (E, Shift+E) to erase them or the Brush tool (B, Shift+B) to paint on them with 50% gray at 100% opacity.

BECAUSE OF THE LOW OPACITY OF THE BRUSH TOOL, THE CHANGE PRODUCED BY A GIVEN BRUSH STROKE SHOULD BE SUBTLE.

☐ SAVE THE FILE

The color image has now been optimized to create the master image file. Save it as a PSD or TIFF file with an appropriate name (e.g., "filename_ Master.psd"). Duplicate this file (Image>Duplicate) and save it as a PSD or TIFF file with a name that indicates a black-and-white master image (e.g., "filename_BW_Master.psd"). Close the master image but keep this duplicate image open—it is now ready to be converted to black-and-white.

Converting a Color Image to Black and White

In this chapter, I will describe basic as well as more advanced methods to convert an image from color to black and white. Some images appear more aesthetically pleasing after conversion by one technique than another. At times, a simple method will yield a great result. Generally, though, I use more sophisticated processes, ranging from multilayer modulation of color channels to third-party plug-ins. The results obtained using different methods on the same image will be

FIGURE 4-1. GRAYSCALE MODE. Choose Image>Mode>Grayscale to convert an image to Grayscale.

shown to allow a comparison of these techniques. As a preliminary step, the color image should be optimized for the black-and-white conversion.

■ OPTIMIZE THE IMAGE FOR BLACK AND WHITE CONVERSION

Although image tonality and color have been adjusted for the master image file, the final black-and-white image may sometimes be improved by exaggerating differences in hue, saturation, or lightness between important elements in the image before converting it to black-and-white. These are the same techniques described in the previous chapter. However, in this instance, the goal is no longer to achieve the best RGB image, but rather to create more separation between tones. One method is to add a new Hue/ Saturation adjustment layer above the image layer and adjust the Hue, Saturation, and/or Lightness sliders in some or all of the individual color ranges. A Color Balance adjustment layer can also be used to modify the relationship between the colors.

a

b

FIGURES 4-2A AND B. COLOR WHEEL. (a) RGB Color. (b) Grayscale conversion.

☐ CONVERT THE IMAGE TO BLACK AND WHITE

Grayscale. The easiest way to convert an image from color to black and white (grayscale) is to choose Image>Mode>Grayscale (fig. 4-1). All color information is discarded, and the image contains only one channel, based upon the luminosity of the image. This method seems especially useful for color images with significant light–dark contrast. Colors of similar lightness (such as red–magenta and green–cyan in figure 4-2) are difficult to differentiate after grayscale conversion. The Grayscale mode image of multicolored prayer flags shows a broad dynamic range (fig. 4-3).

FIGURES **4-3**A AND B. PRAYER FLAGS, KHUNDE. (a) RGB Color (above). (b) Grayscale conversion (right).

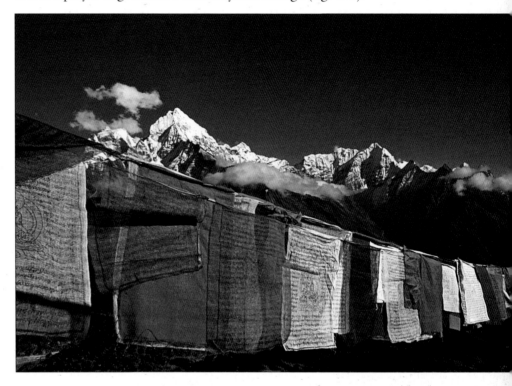

Desaturation. A straightforward technique to convert a color image to black and white is to completely desaturate it so that all color information is removed from the image. Although individual red, green, and blue color channels remain, the relationship between these channels is eliminated. This method is primarily useful when substantial differences in brightness exist in the image.

To desaturate an image, add a Hue/Saturation adjustment layer above the image layer and decrease the Saturation to –100 (fig. 4-4). Based upon the appearance of the desaturated color wheel in figure 4-5, one might conclude that desaturation eliminates all distinctions between colors. As figure 4-6 shows, this is not the case. However, the brightness of each color in the color wheel is the same (100%), which explains the identical appearance of these colors after desaturation. This technique can be refined to enhance differences between the tones in the desaturated image by choosing any or all of the color channels in the Hue/Saturation dialog box and adjusting the Lightness setting of these colors to make them more or less prominent.

FIGURE 4-4. HUE/SATURATION. Moving the Saturation slider to −100 removes all color from the image.

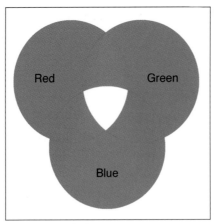

FIGURE 4-5. COLOR WHEEL, DESATURATED. Desaturating the color wheel eliminated differences between the colors.

FIGURE 4-6. PRAYER FLAGS, DESATURATED. Distinction between the colors is maintained in this image. Why is this different from the color wheel image?

Individual Channels. Each color channel in an RGB or CMYK image is a grayscale image that represents the tonal values of that color in the image. Consequently, an individual color channel can be selected as a black-and-white image. To make this selection, go to the Channels palette and click on each color channel to view it separately (fig. 4-7a). In RGB mode, the green channel often contains the most contrast and brightness information. Select the color channel that best represents the feeling of the image, then change to Grayscale mode (Image>Mode>Grayscale) to discard the information in the other color channels. Now return to RGB mode (Image>Mode>RGB Color) so color effects such as toning and tinting can be applied, if desired.

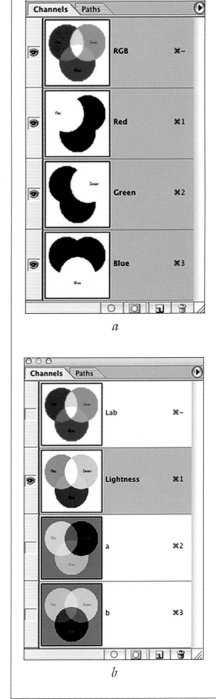

FIGURES 4-7A AND B. COLOR WHEEL, CHANNELS PALETTE. (a) RGB mode. (b) Lab mode. The Lightness channel is highlighted.

The Lightness (L) channel in Lab mode can also be selected as a grayscale image. In Lab mode, the Lightness channel contains all information about tonality, whereas the a and b channels contain all color information. To make the conversion to black and white using Lab mode, duplicate the image (Image>Duplicate), flatten this duplicate image, convert it to Lab color (Image>Mode>Lab Color), and highlight the Lightness channel (fig. 4-7b). Convert the image to grayscale (Image>Mode>Grayscale) to discard the a and b channels, then reconvert the image to RGB color (Image>Mode>RGB Color). Even without additional corrections, this may yield a respectable black-and-white image (figs. 4-8, 4-9).

FIGURE 4-8. COLOR WHEEL, LIGHTNESS CHANNEL. In Lab mode, the Lightness channel contains all tonal information.

FIGURE 4-9. PRAYER FLAGS, LIGHTNESS CHANNEL. Highlighting the Lightness channel after converting the RGB image to Lab mode yields this black-and-white image.

Combined Channels. Rather than using only a single color channel, channels can be combined to improve the conversion to black and white. Thus, the red channel can be combined with the blue or green channel, or the blue channel with the green channel. One way to blend two channels is via Calculations (Image>Calculations). Within the Calculations dialog box, Source 1 and Source 2 default to the active image (fig. 4-10). For both sources, specify the Merged layer to include all image layers (or Background if there is only one image layer). Select one color channel for Source 1 and another for Source 2. Confirm that the Preview box is marked. To average the pixels in the two layers, choose the Add blending mode with Scale factor 2. Different blending modes can be specified. Darken or Multiply can be used to darken the image, and Lighten or Screen to lighten it. The Offset setting specifies a pixel value to be added

to the blended pixels. Positive numbers lighten the image; negative ones darken it. Decrease the opacity if needed to lessen the effect. Set the Result option to New Document to create a new image file containing the composite image. The image color mode will now be Multichannel. To return to the RGB color space, first go to Image> Mode>Grayscale mode, then select Image>Mode>RGB Color. Combining the red and green channels in Add blending mode with Scale factor 2 and Offset 20 yielded the color wheel shown in figure 4-11 and the prayer flag image shown in figure 4-12.

Channel Mixer. An easier way to convert color channel information into a black-and-white image is to use the Channel Mixer, which combines grayscale data from each of the color channels to create a new output channel. When the Monochrome option is checked, the output channel changes to Gray and the image contains only gray tones, even though the color channels remain. This may be considered the digital equivalent of using color filters in black-and-white photography. The Constant option modifies the grayscale value of the output channel, with negative values adding black and positive values adding white.

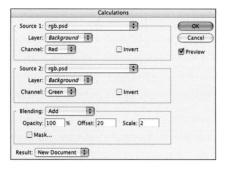

FIGURE 4-10. CALCULATIONS. The pixel values of the red and green channels of the image will be added and averaged, then the resultant pixels values will be increased by 20 to lighten the image, and a new document will be created.

FIGURE 4-11. COLOR WHEEL, CALCULATIONS. The red and green channels of the image have been added using the settings shown in figure 4-10.

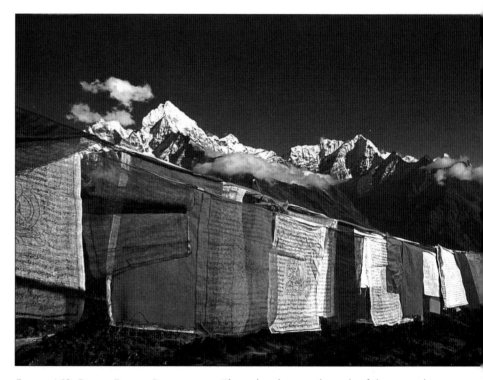

FIGURE 4-12. PRAYER FLAGS, CALCULATIONS. The red and green channels of the image have averaged and increased with offset value 20.

To use this technique, add a Channel Mixer adjustment layer by clicking on the half-black/half-white circle icon at the base of the Layers palette and selecting Channel Mixer from the pop-up menu (fig. 4-13). For RGB images, the Channel Mixer dialog box shows Red, Green, and Blue Source Channels. Place a check mark in the Monochrome box to convert the output to Gray (fig. 4-14). The image now appears similar to one photographed using a red filter with black-and-white film (fig. 4-15a). In most cases, the results can be improved by adding information from the green

and blue channels (fig. 4-15b). The optimal percentage from each channel is so dependent upon the particular image that it is difficult to generalize. A good starting point is to evaluate each of the color channels individually and then assign the highest percentage to the one that looks the best, the lowest percentage to the one that looks the worst, and an intermediate value for the third channel. Adjust the sliders to vary the percentage from each color channel until the tonal balance is optimized. In order to maintain the luminosity of the image, the percentage total from the red, green, and blue channels should equal about 100%. However, this rule is not absolute, and I often use a higher total percentage value.

FIGURES 4-15A AND B. COLOR WHEEL, CHANNEL MIXER. (a) The appearance of the color wheel with the default grayscale setting for the Red channel confirms that all pixels are converted to red. (b) A better conversion can be obtained by adding pixels to the green and blue channels. The same settings were applied to this image as to the flags in figure 4-16.

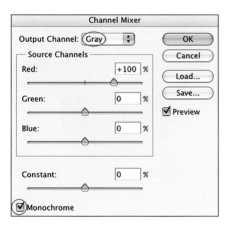

FIGURE 4-13. LAYERS PALETTE, CHANNEL MIXER. A Channel Mixer adjustment layer has been added above the background image.

FIGURE 4-14. CHANNEL MIXER. Selecting Monochrome converts the image to black and white with default settings that derive input only from the red channel.

FIGURE 4-16. PRAYER FLAGS, CHANNEL MIXER. Applying values of Red +80%, Green +20%, and Blue 0% with Constant +5% yielded this grayscale image.

To enhance a blue sky in a black-and-white image using the Channel Mixer, make red the dominant channel and use relatively small percentages of green and blue. To create an effect somewhat similar to an orange filter, try Red +80%, Green +20%, and Blue 0% with Constant +5%. These are the values I used to create figure 4-16. Experiment with other settings, such as Red +90%, Green +5%, and Blue +15% or Red +60%, Green +40%, and Blue +10%. If you find settings you like for a particular type of image, click on the Save button in the Channel Mixer dialog box and assign an appropriate name. By clicking the Load button, you can apply these same settings to subsequent images with similar characteristics.

Gradient Map. The Gradient Map translates the luminosity values of an image to the colors of a gradient. With a two-color gradient, shadows map to the darker color and highlights map to the lighter one. Thus, when a Black–White gradient is selected in the Gradient Map dialog box, the shadows of the image are mapped to black and the highlights to white. While evaluating the optimal method for converting color images to black and white, I determined that the Gradient Map represents a novel method to accomplish this.

To convert an image to black and white using this technique, click on the half-black/half-white circle icon at the bottom of the Layers palette and select Gradient Map from the pop-up menu. Within the Gradient Map dialog box, check the Dither box to smooth the appearance of the gradient fill (fig. 4-17). Make certain the Preview box is checked so you can see the effect on your image. Now click on the gradient displayed in the Gradient Map dialog box to open the Gradient Editor (fig. 4-18). Select the Black, White gradient from the Presets at the top of the Gradient Editor dialog box. In the lower section of the box, the active gradient is shown with controls known as "stops" that control the opacity and colors of the gradient. Click on the left (black) or right (white) Color Stop along the bottom of the gradient to reveal a small diamond midway between the black and white Color Stops. Known as the Color Midpoint, this diamond can be moved to the left to lighten the midtones or to the right to darken them. Wait to click on the diamond until the cursor has changed from a hand to an arrow—otherwise you will add an additional Color Stop. You will need to release the mouse button after dragging the midpoint to see the change in image tonality. Adjustment of the Color Midpoint has turned out to be an essential component of my successful use of the Gradient Map to convert images to black and white, since images otherwise tend to be too dark. If necessary, the black Color Stop can be moved to the right to shift the midtones toward the shadows, or the white Color Stop can be moved to the left to shift the midtones toward the highlights. This is analogous to tonal adjustments using Levels, and it offers an intuitive, visual approach to modifying the contrast and brightness of a black-and-white image. When the adjustments are completed, click OK to close the Gradient Editor dialog box, then click OK again to close the Gradient Map dialog box and apply the

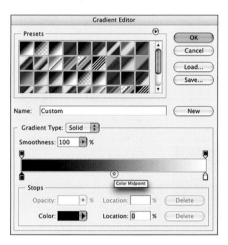

FIGURE 4-17. GRADIENT MAP. Click on the gradient to open the Gradient Editor.

FIGURE 4-18. GRADIENT EDITOR. Select Black, White gradient, then click on the black Color Stop at the lower left of the gradient. The name of the gradient will change to Custom, and the Color Midpoint will become visible.

FIGURE 4-19. COLOR WHEEL, GRADIENT MAP. This conversion to black and white was made with the Gradient Map using a Black, White gradient with Color Midpoint 40.

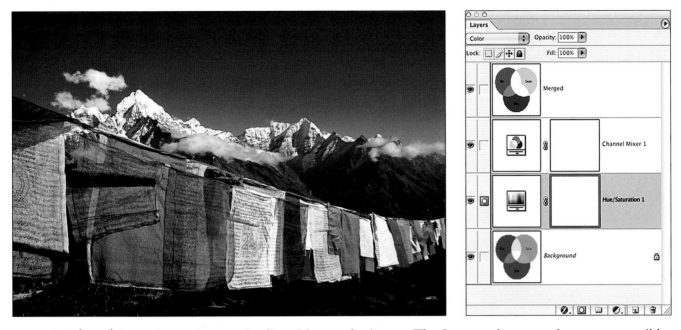

FIGURE 4-20 (ABOVE). PRAYER FLAGS, GRA-DIENT MAP. The same settings were applied to this image as described in figure 4-19.

FIGURE 4-21 (ABOVE RIGHT). MULTICHANNEL CONVERSION. A Channel Mixer adjustment layer converts the image to grayscale, but the effect is modulated by the color output from the Hue/Saturation layer. A thumbnail of the converted image is shown in the top merged layer.

FIGURE 4-22. COLOR WHEEL, HUE/SATURA-TION–CHANNEL MIXER CONVERSION. By fine-tuning the individual color ranges in the layers, each color can be adjusted to the desired tonality in the grayscale image.

Gradient Map to the image. The Layers palette now becomes accessible, showing the Gradient Map adjustment layer above the color image layer. The black-and-white conversions shown in figures 4-19 and 4-20 were created using a Gradient Map adjustment layer with a Black, White gradient modified by shifting the Color Midpoint to the left to a location 40% of the way between the black and white stops.

Multilayer Conversion. More complex adjustments can be made by filtering the input to a Hue/Saturation, Channel Mixer, or Gradient Map decolorizing layer via a Hue/Saturation, Channel Mixer, Selective Color, or Color Balance adjustment layer. To apply this method using a Hue/Saturation layer as a filter, open an image, add a Channel Mixer adjustment layer above the image layer, and convert the image to black-and-white by checking the Monochrome box. Set the red, green, and blue color channel percentages as described in the Channel Mixer section. Now add a Hue/Saturation adjustment layer between the image layer and the Channel Mixer layer (fig. 4-21). Change the blending mode of this new layer from Normal to Color and adjust the Hue, Saturation, and/or Lightness channels to optimize image tonality. To fine-tune the image, select individual color ranges (reds, yellows, greens, cyans, blues, and magentas) from the Edit menu in the Hue/Saturation dialog box and adjust the Hue, Saturation, and/or Lightness for each of these colors. To apply this technique to a specific object in the image, select a color from the Edit menu, click on the object to set its precise color range, then adjust the Hue/Saturation settings. Repeat this process for objects with different color ranges. Applying varying degrees of Hue, Saturation, and/or Lightness adjustments to different objects provides virtually unlimited control over the image (fig. 4-22). A black-and-white image produced by a Channel Mixer adjustment layer (Red +80%, Green +20%, and Blue 0% with Constant +5%) above a Hue/Saturation layer in Color blending mode is

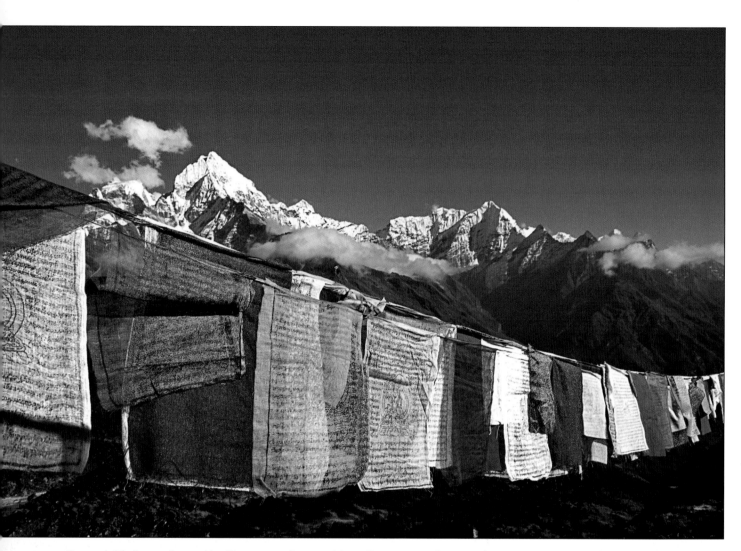

FIGURE 4-23. PRAYER FLAGS, HUE/SATURATION-CHANNEL MIXER CONVERSION. Compare the difference in tonality between the flags to that in figure 4-16, where the same Channel Mixer settings were applied without modulation by the Hue/Saturation layer.

shown in figure 4-23. In order to emphasize some of the prayer flags in the foreground, I selected individual color ranges from the Edit menu at the top of the Hue/Saturation dialog box and then clicked on specific flags to set the color range, adjusting the Hue and Saturation of these color ranges until I achieved better differentiation between the tones in the prayer flags.

In a variation on this technique, I have used a Selective Color adjustment layer in Normal or Color blending mode as the filter between the image layer and the Channel Mixer layer. This allows adjustment of the CMY components of reds, yellows, greens, blues, magentas, whites, neutrals, and blacks. In addition to adjusting the tonal balance of the image by moving the color sliders, one can lighten or darken a color by increasing or decreasing the amount of black in that color. In the prayer flag image, I was able to lighten the red flag to a tone between that of the flag on either side by adjusting the amount of black in the reds. The appearance of the image

FIGURE 4-24. PRAYER FLAGS, SELECTIVE COLOR ADJUSTMENT. This figure depicts the image as modified by the Selective Color adjustment layer before presentation to the Channel Mixer adjustment layer.

FIGURES 4-25A AND B. PRAYER FLAGS, SEL-ECTIVE COLOR MULTICHANNEL CONVERSION. (a) Combination of Selective Color adjustment layer with a Channel Mixer adjustment layer (top). (b) Combination of Selective Color adjustment layer with a Gradient Map adjustment layer (bottom).

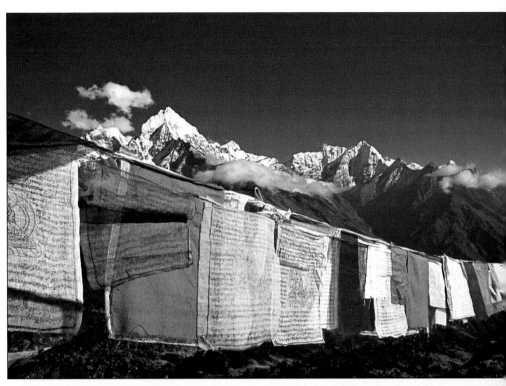

FIGURE 4-26. "HAMILTON DECOLORIZER." Hue/Saturation, Selective Color, Gradient Map, and Curves adjustment layers are included within a single layer set to facilitate black-and-white adjustments.

as modified by the Selective Color adjustment layer before presentation to the Channel Mixer is illustrated in figure 4-24. The result of applying the Channel Mixer adjustment to this Selective Color output is shown in figure 4-25a. In a further modification of this concept, I have used a Gradient Map adjustment layer to decolorize images filtered by a Hue/Saturation adjustment layer in Color blending mode and/or a Selective Color adjustment layer in Normal or Color blending mode (figs. 4-25b, 4-26).

Once you find the combination of adjustment layers and settings that yields results to your liking, I recommend that you create a Photoshop Action and assign it a shortcut key to facilitate image conversion using this technique. My "Hamilton Decolorizer" Photoshop Action adds Hue/Saturation and Selective Color adjustment layers between the image and a Gradient Map adjustment layer, then sets the white and black points. These adjustments are included within a gray color-coded set that can be modified by adjusting the opacity or blending mode or by adding a mask to the layer set to apply the effect selectively.

Channels as Layers. To create a black-and-white image using more complex blending of the color channels, each color channel can be copied into the Layers palette using a technique popularized by Jean Paul Caponigro. Go to the Channels palette and highlight the Blue channel. Press Command/Control+A to select the channel and Command/Control+C to copy the Blue channel to the clipboard. Select the RGB composite channel, then press Command/Control+V to paste the Blue channel into the Layers palette above the color image layer (fig. 4-27). Click the eye icon beside the Blue layer to hide it, then select the color image layer. Return to the Channels palette and perform the same steps to copy and paste the Green channel into the Layers palette. Hide the Green layer, select the color image layer, and repeat the sequence to copy the Red channel and paste it into the Layers palette.

To maintain flexibility in adjusting the opacity of the individual color channel layers, place a grayscale image at 100% opacity above the color image layer. The easiest way to accomplish this is to highlight the color image layer and click on the half-black/half-white circle icon at the base of the Layers palette to add a Hue/Saturation adjustment layer, then decrease the Saturation of the layer to –100. Unfortunately, as demonstrated above, desaturation does not yield the best black-and-white conversion. A better method is to duplicate the original image (Image>Duplicate) and convert it to Lab mode (Image>Mode>Lab Color). Highlight the Lightness channel, press Command/Control+A and Command/Control+C to select and copy the channel, then return to the RGB image, highlight the color image layer and press Command/Control+V to paste the Lightness channel between that layer and the color channel layers.

Now adjust the opacity of each color channel layer to specify its contribution to the black-and-white image. Position the layer with the highest opacity at the bottom and the layer with the lowest opacity at the top. The Lightness channel layer should remain below the other channel layers with opacity fixed at 100%, unless a tinting effect is desired. I applied this approach to the prayer flags image, setting the opacity of the red channel layer to 80%, the green channel layer to 20%, and the blue channel layer to 5%, to produce the black-and-white image shown in figure 4-28.

The power of this technique is derived from the ability to edit individual color channel layers. Add a mask to the layer and paint on it with black

FIGURE 4-27. LAYERS PALETTE, CHANNELS AS LAYERS. The position of the original color image layer, Lightness channel, and RGB channels is shown. Each of the color channels is a grayscale image with layer opacity adjusted as indicated in the figure and text.

FIGURE 4-28. PRAYER FLAGS, CHANNELS AS LAYERS CONVERSION. Using the color channels as grayscale image layers over the Lightness channel as depicted in figure 4-27 yielded this black-and-white image.

or gray to limit the contribution of that layer to selected areas of the image. Different layer blending options can also be applied. By placing all of the black-and-white layers in a set, the opacity of the set can be decreased to colorize the image, or a mask on that layer set can be painted with black or gray to apply color selectively within different sections of the image. Although setting up the Layers palette as described is somewhat time-consuming, that limitation can be overcome by creating a Photoshop Action to apply these steps. The major disadvantage of this technique is that the resulting file size can be quite large.

Camera Raw. If you are shooting with a digital camera and saving your images as raw image files, the images can be converted to black and white using the Photoshop Camera Raw plug-in. After opening the image in Camera Raw, locate the Saturation slider at the lower right of the Camera Raw dialog box and slide it all the way to the left to −100. This converts the image to black and white. Within Camera Raw, you can modify tonality by adjusting the Temperature, Tint, Exposure, Shadows, Brightness,

and Contrast sliders. In addition, if you click on the Calibrate tab (visible when the Advanced button is marked), you can further adjust the tonality by changing the Shadow Tint, Red Hue, Red Saturation, Green Hue, Green Saturation, Blue Hue, and Blue Saturation. This provides a lot of tonal control! If you find a setting you particularly like, save it by clicking the arrowhead to the right of the Settings pop-up menu.

To simplify these conversions for Photoshop CS users, Adobe Photoshop guru Russell Brown has developed a set of Camera Raw configurations known as "Dr. Brown's RAW Photo Styler." The good "doctor" has been known to provide this utility to Photoshop devotees without charge—details are available at www.russellbrown.com. The Photo Styler can be accessed either from Camera Raw via XMP files or from Photoshop via a Java script. Within the CD entitled "Dr. Brown's Image Processor" is a folder of XMP files known as Photo Styler XMP Files—these are the files that contain Camera Raw settings. Copying these files into the Camera Raw folder within the Presets folder of Adobe Photoshop CS allows them to be accessed from Camera Raw. To use the Photo Styler, click on the Settings pop-up menu in the Camera Raw dialog box to display a listing of available black-and-white effects identified by the preface BW, including Black Light, Bright Sky, Darker Blues, Darker Reds, Day for Night, Enhanced Blue, and Tonal Balance (fig. 4-29a). Selecting any of these will apply settings to the Adjust and Calibrate options that yield a particular black-and-white effect (fig. 4-29b).

FIGURES 4-29A AND B. CAMERA RAW. (a) Photo Styler Menu. (b) Black-and-White Conversion. The Photo Styler effect called BW Tonal Balance has been selected. Among other adjustments, the saturation has been decreased to −100, creating a black-and-white image.

With these Photo Styler presets as a foundation, you can adjust the settings to modify the tonality of the image. For example, after opening a raw image of a pig and bamboo rafts graciously provided by Nevada Wier (fig. 4-30a), I selected Black Light from the Settings menu and changed the brightness to 30 to yield the image shown in figure 4-30b. To illustrate the diverse tones that can be produced using the Photo Styler, I also applied the Tonal Balance effect to the image, as shown in figure 4-30c.

Russell Brown has expanded the Photo Styler options with a Java script utility that is also included on "Dr. Brown's Image Processor" CD. To install this utility, make certain Photoshop CS is closed and copy the file named "Dr. Brown's RAW Photo Styler.js" into the Scripts folder located at Applications>Adobe Photoshop CS>Presets>Scripts. To use this variation

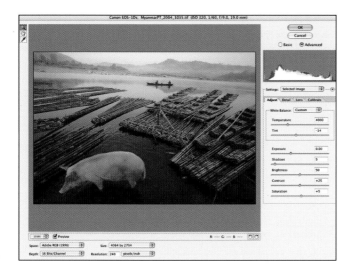

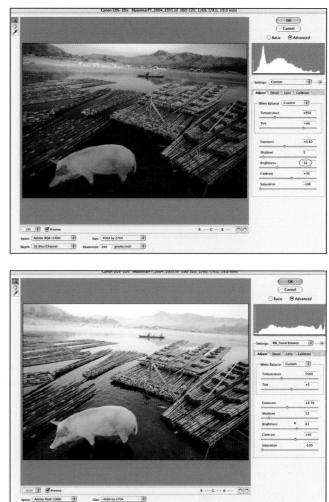

FIGURES 4-30A, B, AND C. CAMERA RAW. (a) Canon EOS-1Ds digital image, bamboo camp near Mrauk U, Myanmar (above left). (b) Black Light Photo Styler effect (above right). (c) Tonal Balance Photo Styler effect (right). Image copyright 2004 by Nevada Wier (www.nevadawier.com). All rights reserved. Used with permission.

FIGURE 4-31. SCRIPTS MENU. The Java script Photo Styler is launched from this menu.

of the Photo Styler, open Photoshop CS and go to File>Scripts>Dr. Brown's RAW Photo Styler (fig. 4-31). If an image has been selected in Photoshop's File Browser, its name will appear in the Photo Styler dialog box (fig. 4-32a). Check the box to use the Selected Image as Source, or Browse to select another image. Within the Photo Style Mode section is a listing of the available modes, including the same black-and-white effects described above using the Photo Styler XMP files in Camera Raw. Select the modes you wish to preview, then specify the layout of the contact sheet for these modes. Press Run to apply the selected styles to your image and to create a contact sheet of the resultant images (fig. 4-32b).

Advanced blending effects can be achieved by combining and masking black-and-white images produced using different Photo Styler settings. To try this, select the black-and-white image that most closely matches the desired result. Then select another image that possesses characteristics you would like to incorporate into the image. Press V to select the Move tool and drag the second image on top of the first image while holding the Shift key to center it. Go to the Layers palette and note that the image you moved is now highlighted as Layer 1 above the Background layer. Option/

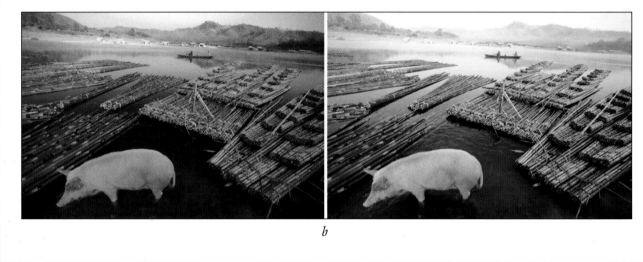

FIGURES 4-32A AND B. PHOTO STYLER, JAVA SCRIPT MODE. (a) Using the Java script Photo Styler mode, multiple effects can be applied at the push of the Run button. (b) Contact sheet generated by Photo Styler showing Black Light and Tonal Balance effects.

Alt+click on the Add Layer Mask icon at the base of the Layers palette to add a mask that hides Layer 1. To blend the layers, paint on the layer mask with white using a soft brush with opacity of 20 to 30% to reveal the desired components of the upper image, or create a black-to-white gradient on the layer mask so the white portion of the gradient encompasses the desired area of the upper image. I used this approach to blend the Black Light and Tonal Balance black-and-white conversions of the Nevada Wier image (fig. 4-33a) to produce the composite image shown in figure 4-33b. This blending effect can be modified by using different blending modes, such as Soft Light, Overlay, and Hard Light, or decreasing the opacity of the upper layer. If desired, additional images can be added to this composite, providing the potential for seemingly unlimited variations.

Third-Party Filters. Although it is possible to produce excellent black-and-white conversions using Photoshop alone, several companies have cre-

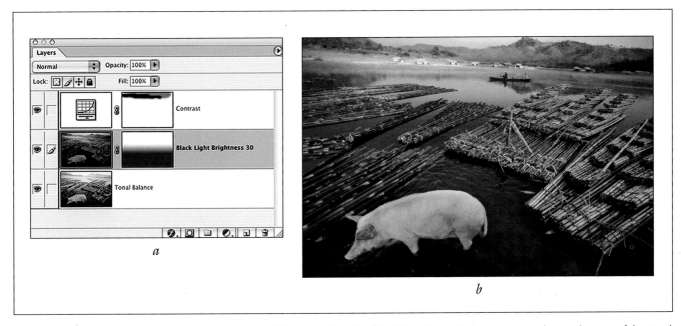

FIGURES 4-33A AND B. LAYERED PHOTO STYLER EFFECTS. (a) Layers palette. The Black Light Photo Styler image was dragged on top of the Tonal Balance Photo Styler image and a gradient applied to the layer mask to blend the images. The image contrast has been increased slightly using a Curves adjustment layer. (b) Composite image, Black Light and Tonal Balance Photo Styler effects. Image copyright 2004 by Nevada Wier.

ated plug-in filters for Photoshop (and other imaging programs) that may simplify the process.

Fred Miranda BW Workflow Pro. This relatively inexpensive program offers a convenient means of converting an image to black and white. Available from www.fredmiranda.com, this software does not offer the option of a trial before purchase. To open the dialog box, go to File> Automate>BW Workflow Pro. If your image has layers, a message will appear indicating that this plug-in works only on flattened images. Thus, you will not be able to maintain layers. Make certain that this image is a duplicate and not the original. After the image is flattened, if needed, a dialog box as shown in figure 4-34 appears, offering a number of options. If Preset Mode is selected, the image can be converted to black and white with or without simulating the effect of a color filter. An alternative conversion mode named Smart Mix is similar to Photoshop's Channel Mixer but automatically adjusts the percentages of red, green, and blue to keep the total at 100%. Manual Mode allows selection of any percentage values for the RGB channels. Toning effects that are meant to simulate duotones, tritones, and quadtones can be added to the basic black-and-white effect. Selecting the Preset Mode with B&W (no filter) and no additional effects yielded the image shown in figure 4-35.

Pixel Genius Photo Kit. Costing a bit more BW Workflow Pro, Photo Kit features color to black and white conversion options that include twelve different color contrast effects. The contrast effects must be applied individually to find the one that yields the best black and white conversion, since it is not possible to preview a result before the filter is applied. A fully-

FIGURE 4-34. BW WORKFLOW PRO DIALOG BOX.

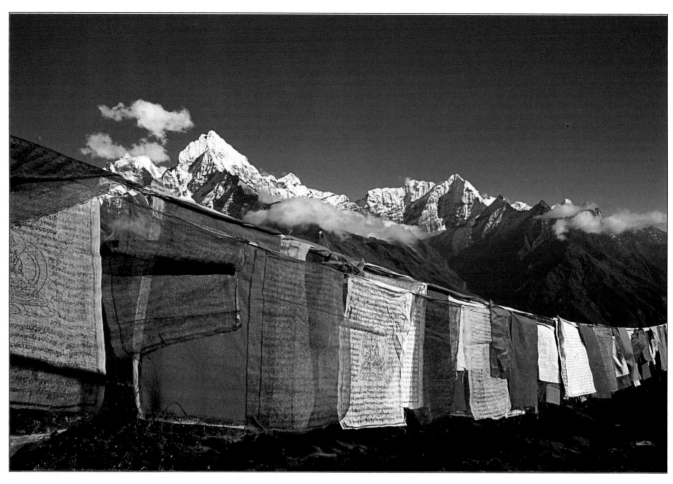

FIGURE 4-35. PRAYER FLAGS, BW WORKFLOW PRO CONVERSION.

functional trial program can be downloaded from www.pixelgenius.com and used for 7 days before purchase is required.

nik Color Efex Pro. The B/W Conversion filter, available as part of the nik Color Efex Pro package, has been one of the more popular of the third party plug-in filters. Color Efex Pro 2, an updated version of the program, includes the B/W Conversion filter in addition to two new black-and-white conversion filters: Dynamic Range and Tonal Enhancer. Among these filters, I have found the Tonal Enhancer most useful. In addition to these new filters, the updated program offers other enhancements.

B/W Conversion filters can be accessed from the Photoshop menu item Filter>nik Color Efex Pro 2: Traditional Filters. However, an easier way to use these filters is from the Color Efex Pro 2: Selective tool, a window that can be configured to open with Photoshop (or otherwise can be opened from the menu item File>Automate>nik Color Efex Pro 2: Selective). The filter options are the same as within the Filter menu, but the Selective tool automatically adds and labels a merged copy of the image to the top of the layers stack. One can bypass adding the merged layer and mask by pressing Shift while clicking on the filter to select it, but I appreciate having the merged layer created and labeled automatically.

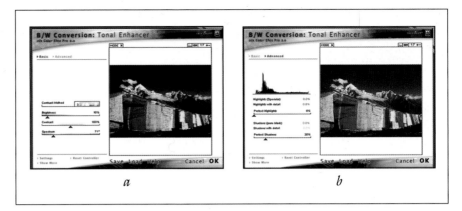

FIGURES 4-36A AND B. COLOR EFEX PRO B/W CONVERSION TONAL ENHANCER. (a) Basic dialog box features controls for Contrast Method, Brightness, Contrast, and Spectrum. (b) Advanced dialog box displays a histogram with sliders to protect highlights and shadows.

The dialog box for B/W Conversion Tonal Enhancer, shown in figure 4-36a, offers a choice of three Contrast Methods, in addition to sliders for Brightness, Contrast, and Spectrum. An Advanced option shows a histogram of the image and allows the highlights and shadows to be protected to varying degrees by moving the sliders. For example, when converting the prayer flag image, I monitored the histogram as I moved the Protect Shadows slider from its default value of 0% over to 20%, thereby maintaining detail in the shadows (fig. 4-36b). When using the Selective tool, a black layer mask will hide the effect of the filter until the Fill button is pressed. To apply the black-and-white effect only to selected elements in the image, click on the Paint button, then paint on the image to replace color with the black-and-white filter effect. If you view the Layers palette, you will see that you are actually painting with white on the black layer mask to reveal the effect. To keep the filter conversion, click on the Apply button. The resultant prayer flag image, converted using Contrast Method 3 with default settings, except for protecting the shadows, is shown in figure 4-37.

IF YOU VIEW THE LAYERS PALETTE, YOU WILL SEE THAT YOU ARE ACTUALLY PAINTING WITH WHITE ON THE BLACK LAYER MASK TO REVEAL THE EFFECT.

Settings applied using a particular filter can be saved for use at a later time. The Color Efex Pro 2 filters also support Photoshop actions, droplets, and batch processing. One caveat when using the Selective tool is that if a visible (not hidden) image layer is present immediately below the new layer containing the converted image, the new layer will merge down and consume the image layer below. Unless you are applying the filter to a duplicate image and do not want to preserve the color image layer, this is not a good idea. To prevent this from happening, click the Settings box on the Selective dialog box and check the Keep as Layer option.

Other Software. Other software products that convert color to black and white or produce black-and-white effects are also available. These include

FIGURE 4-37. Prayer Flags, Color Efex Pro B/W Conversion: Tonal Enhancer.

AutoFX Software's Mystical Tint Tone and Color filters; Digital Film Tool's 55MM digital filter set; Power Retouche's Black & White Studio and Toned Photos plug-ins; and Silver Oxide's Black and White filters, Warm/Sepia Toning filter, and Silver IR filter.

☐ APPLY FINAL BLACK-AND-WHITE TONAL CORRECTIONS

After completing the conversion to black and white, image tonality should be reassessed. Some images may appear a little flat after conversion. Others may have highlights that are too light or shadows that are too dark. A Levels or Curves adjustment layer can be added to adjust the contrast or brightness of the image. Some images may also benefit from localized dodging and burning to enhance specific elements.

Colorizing a Black-and-White Image

Black-and-white images, whether derived from black-and-white film or converted from color images using the techniques described in the previous chapter, produce attractive prints. Yet, many outstanding black-and-white prints are not truly grayscale, but rather have a tint or tone applied. In the traditional darkroom, toning results from the chemicals used to process the photographic paper. Selenium imparts a cool, purplish tone. Silver sulfide produces brown tones associated with sepia prints. Ferric ammonium citrate adds brown tones ranging from light sepia to dark brown in Van Dyke prints. A mixture of ferric ammonium citrate and potassium ferricyanide creates the pale to deep-blue color characteristic of cyanotype prints.

This chapter describes colorizing techniques that can be applied to black-and-white images in the digital darkroom to simulate and expand upon traditional effects. In some instances, a uniform tone will be added to the image. In others, one or more colors will be introduced to emulate split-toning or hand-tinting. To utilize tinting or toning effects, the image must reside in RGB color space (Image>Mode>RGB Color), except for duotones.

■ HUE/SATURATION

One of the easiest ways to tone an image is to apply a Hue/Saturation adjustment. Click on the half-black/half-white circle icon at the bottom of the Layers palette to add a Hue/Saturation adjustment layer. Place a check in the Colorize box in the lower right corner of the Hue/Saturation dialog box. The image will now appear tinted, with default values of Hue 0 (red) and Saturation 25%. Move the Saturation slider to set the intensity of the tint, then move the Hue slider to choose the color (fig. 5-1). By varying the Hue and Saturation sliders, virtually any toning effect can be reproduced. For example, a sepia-toned print can be created by changing the Hue to 30 and Saturation to 25. More subtle sepia toning can be achieved by using Hue 25 and Saturation 15. The amount of toning can also be reduced by decreasing the opacity of the Hue/Saturation layer.

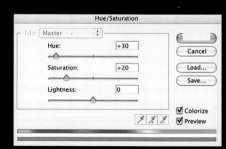

FIGURE 5-1. HUE/SATURATION OPTIONS. These settings were applied to the image in figure 5-2 to yield a sepia tone.

FIGURES 5-2A AND B. HUE/SATURATION, SEPIA. (a) Original Tri-X image (top). (b) Image after applying Hue/Saturation adjustment (above).

Using this approach, I added a sepia tone to an old Tri-X black-and-white image that had lain dormant in my archives until resurrected in the digital darkroom (fig. 5-2a). Although I liked the original tone of the image, I decided to add a Hue/Saturation adjustment layer, setting the Hue to 30 and the Saturation to 20 to yield the final image (fig. 5-2b).

☐ CHANNEL MIXER

In addition to converting an image to black-and-white, the Channel Mixer can be used as an adjustment layer over a black-and-white image to apply a tint by leaving the Monochrome box unchecked and setting the proper blend of red, green, and blue for each of the RGB channels. A sepia tone can be produced by applying values of Red +30%, Green +70%, Blue +8%, and Constant +8% in the Red channel; Red +25%, Green +75%, Blue +8%, and Constant +4% in the Green channel; and Red +25%, Green +70%, Blue +15%, and Constant –2% in the Blue channel (figs. 5-3, 5-4). A cyanotype can be simulated by entering settings of Red –62% and Blue +138% in the

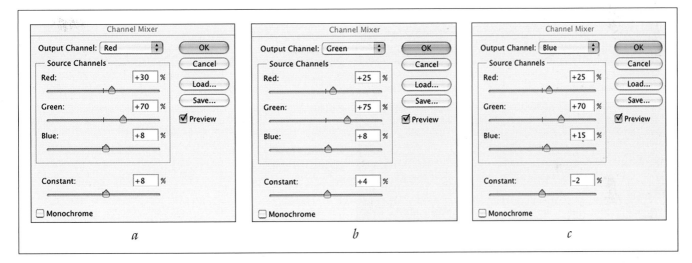

FIGURES 5-3A, B, AND C. CHANNEL MIXER SETTINGS FOR SEPIA. (a) Red channel. (b) Green channel. (c) Blue channel.

FIGURES 5-4A, B, AND C. CHANNEL MIXER, SEPIA. (a) Original Velvia image. (b) Image after black-and-white conversion using nik B/W Conversion filter. (c) Sepia effect created by adding Channel Mixer adjustment layer with settings shown in figure 5-3.

Red channel combined with Blue +118% in the Blue channel. These settings were applied to the image shown in figure 5-5, where the opacity of the Channel Mixer layer was decreased to 65% to lessen the amount of toning. To use the same combination of color values for future conversions, press the Save button in the Channel Mixer dialog box and give the file an appropriate name; to reuse these settings, click on the Load button in the Channel Mixer dialog box and locate the appropriate file.

a *b*

FIGURES 5-5A, B, AND C. CHANNEL MIXER, CYANOTYPE. (a) Original Velvia image. (b) Image after B/W Conversion filter. (c) Cyanotype effect produced by adding Channel Mixer adjustment layer with settings as described in text.

c

☐ COLOR BALANCE

A Color Balance adjustment layer can also be used to tone a black-and-white image. For example, applying Color Balance settings of Red +20, Green +10, and Blue −10 to the Midtones of a black-and-white image yields a subtle sepia tone (fig. 5-6). Try various proportions of cyan vs. red, magenta vs. green, and yellow vs. blue to tone the image. With a little experimentation, you can devise settings for different toning effects to colorize your images. Although Color Balance does not allow the settings to be saved, Photoshop Actions can be created to apply these same settings to other images.

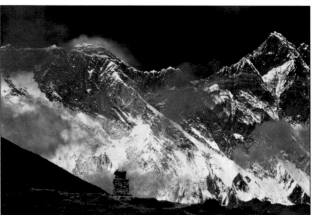

a

b

FIGURES 5-6A, B, AND C. COLOR BALANCE, SEPIA. (a) Original Velvia image. (b) Image after B/W Conversion filter. (c) Sepia tone applied with Color Balance adjustment layer settings per text.

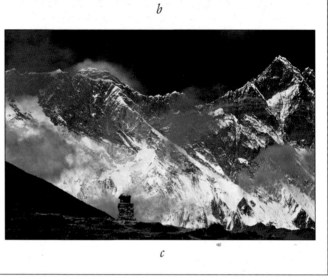

c

□ COLOR FILL

This method places a Color Fill adjustment layer above a grayscale image to apply a colored tint, analogous to using a colored filter in the field or chemical darkroom. In addition to varying the color of the filter, the intensity and quality of the effect can be modulated by changing the blending mode and opacity of the layer. To use this technique, add a new Color Fill adjustment layer above a black-and-white image layer by clicking on the half-black/half-white circle icon at the bottom of the Layers palette and selecting Solid Color from the pop-up menu. This opens the Color Picker dialog box, allowing you to select a color to tone the image. After choosing the desired color from the Color Picker or Custom Colors (accessed by clicking on the Custom button in the Color Picker dialog box), click OK to create the Color Fill adjustment layer (fig. 5-7). Since the default blending mode of the layer is Normal with 100% Opacity, the underlying image will be obscured by the Color Fill layer. To make the image visible, click on the blending mode pop-up menu at the upper left of the Layers palette and change the mode of the layer from Normal to Color. Other blending modes, particularly Soft Light and Overlay, may also produce pleasing tones. To decrease the intensity of the color, lower the opacity of the Color

Fill layer until the desired effect is achieved. Applying a Color Fill adjustment layer filled with Pantone Warm Gray 11C from Custom Colors created the sepia-toned ginger flower shown in figure 5-8.

☐ PHOTO FILTER

With Photoshop CS, Adobe introduced the Photo Filter, a method of adding a color tint similar to a Color Fill layer. Designed to simulate the effect of applying a color filter to a camera lens, Photo Filter can be ac-

a

FIGURES 5-7A AND B. COLOR FILL. (a) The Custom Colors dialog box, accessed by clicking on the Custom button in the Color Picker dialog box. (b) The Layers palette, showing the position of the Color Fill layer with the thumbnail depicting the color; the blending mode of this layer was changed to Color.

b

FIGURES 5-8A, B, AND C (BELOW). COLOR FILL SEPIA. (a) Original Velvia image. (b) Image after B/W Conversion filter. (c) Sepia tone blended using a Color Fill adjustment layer using Pantone Warm Gray 11C.

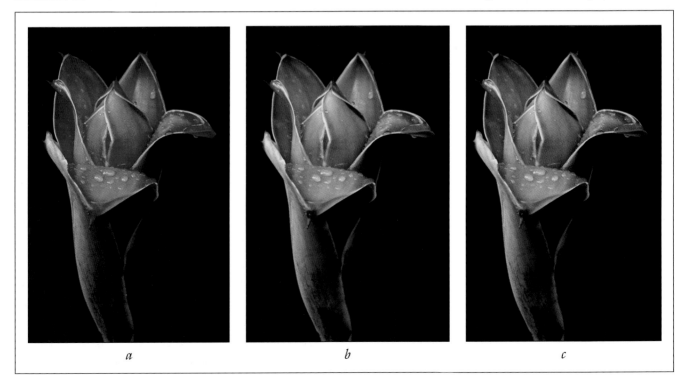

a　　　　*b*　　　　*c*

FIGURE 5-9. PHOTO FILTER, COOLING FILTER.

cessed from the adjustment layer menu. Preset Photo Filter colors include warming (81 and 85) and cooling (80 and 82) filters, the colors of the rainbow, sepia (for use with black-and-white images), deep red, deep blue, deep emerald, deep yellow, and underwater (fig. 5-9). Custom colors can be selected by clicking on the color swatch in the dialog box to launch the Color Picker. The default Density for these colors is 25%, but weaker or stronger toning can be achieved by adjusting the density setting. Applying the cooling (80) filter at its default density yielded the blue toning of the Fishermen's Bastion shown in figure 5-10.

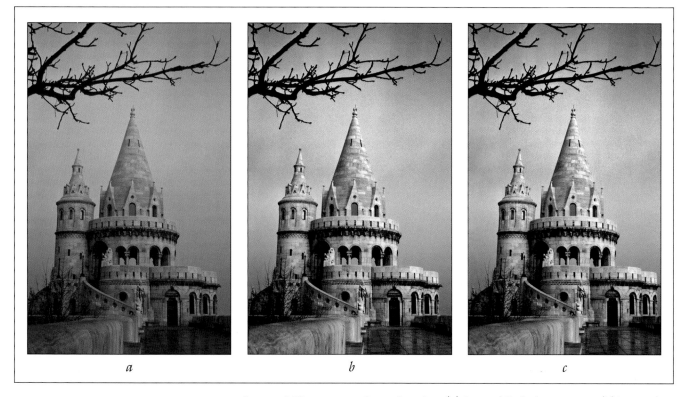

FIGURES 5-10A, B, AND C. PHOTO FILTER, BLUE. (a) Original Kodachrome image. (b) Image after B/W Conversion and tonal adjustments. (c) Cool tone imparted by Photo Filter adjustment layer with Cooling Filter (80) at 25% density.

☐ LAYER STYLE COLOR OVERLAY

An effect similar to that created with the Color Fill and Photo Filter adjustment layers can also be produced using a Layer Style on a regular (not background) layer. The simplest way to access the Color Overlay blending option is to click on the icon that looks like the letter "f" in a circle at the bottom of the Layers palette and choose Color Overlay (fig. 5-11a). Set the Blend Mode to Color, then click on the color swatch to the right of the Blend Mode to open the Color Picker. Select the desired color and click OK. Now preview the image as you adjust the opacity of this color (this is not the opacity of the layer). If desired, additional Layer Style effects can be selected from the Blending Options column. After you click OK, the Layers palette will reveal the Layer Style icon on the image layer, with each

blending option applied to the image shown as a separate effect attached to the layer (fig. 5-11b). The result of applying a red color overlay at 20% opacity in Color blending mode to a black-and-white image is shown in figure 5-12.

FIGURES 5-11A AND B. LAYER STYLE, COLOR OVERLAY. (a) The Color Overlay dialog box shows the Color blending mode for red (selected from the color swatch) at 20% opacity. (b) The Layers palette shows that Color Overlay has been applied to the image layer. Double-click on the Color Overlay effect to change the settings.

FIGURES 5-12A, B, AND C. LAYER STYLE, COLOR OVERLAY. (a) Original Velvia image. (b) Image after B/W Conversion filter. (c) Pink tone applied to flower using settings in figure 5-11a.

FIGURES 5-13A AND B. COLOR FILL. (a) The Fill dialog box, accessed from the menu item Edit>Fill. In addition to Color, options include Foreground Color, Background, Pattern, History, Black, 50% Gray, and White. (b) Layers palette after filling duplicate image layer with color.

☐ LAYER FILL WITH COLOR

An alternative method of toning an image fills the image pixels rather than an adjustment layer with color. To preserve the original image pixels, create a duplicate or merged image layer to which this color fill will be applied. Select Edit>Fill from the menu bar, choose an appropriate color using Color, Soft Light, or another blending mode at reduced opacity, such as 20 to 50% (fig. 5-13a). Select the Preserve Transparency option. The image will now be toned with the selected color (fig. 5-13b). This effect appears similar to adding a Color Fill adjustment layer with the same blending mode and opacity.

☐ AVERAGE COLOR TINT

Another technique I use tints a black-and-white image with the average color of the original image. To use this method, convert a color image to black and white, then select the color image layer and press Command/Control+J to duplicate it. With the duplicate color layer highlighted, select Filter>Blur>Average (fig. 5-14). Drag this filtered layer above the black-and-white image layer and change its blending mode to Color. The result is an image tinted with its average color (fig. 5-15). If the image appears overly colorized, decrease the opacity of the layer or add a Hue/Saturation adjustment layer and decrease the saturation. Other blending modes, such as Soft Light and Overlay, can also be tried. To determine the effect of a tint with the complementary color, select the average filter layer and press Command/Control+I to invert the color. These maneuvers typically yield both a warm and a cool image from which to choose.

FIGURE 5-14. AVERAGE COLOR LAYERS. The average color layer in Color blending mode at reduced opacity tints the black-and-white image created using a multilayer decolorizer.

FIGURES 5-15A, B, AND C. AVERAGE COLOR TINT. (a) Original Velvia image. (b) Black-and-white image created by combining Hue/Saturation and Gradient Map adjustment layers. (c) Toning of image with its average color at reduced opacity.

☐ BLENDING LAYERS TO LIMIT COLORIZATION

Most techniques to colorize images apply equal amounts of color to the highlights and shadows. The tonal range to which colors are applied can be limited by using blending layers, which specify how pixels from the active layer blend with pixels from the underlying layers. This offers a powerful method to replace part of one layer with another or to limit the tonal range modified by an adjustment layer.

To use blending layers, double-click to the right of the layer name to open the Layer Style dialog box (fig. 5-16a). The Advanced Blending section contains controls for blending the active layer with the underlying visible layers. By default, all colors are included in the blending range (Blend If: Gray), but blending can also be limited to an individual color by selecting that channel. The This Layer and Underlying Layer sliders specify the brightness range of the pixels to be blended on a scale from 0 (black) to 255 (white). The This Layer sliders determine which pixels from the active layer will appear in the final image. Pixels on the active layer with values to the left of the black slider or to the

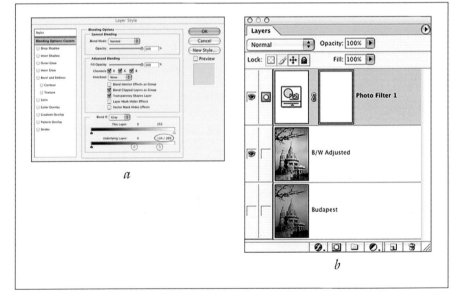

FIGURES 5-16A AND B. LAYER BLENDING. (a) The settings in the Underlying Layer section indicate which pixels from the underlying layers will blend with those on the active layer and which pixels will replace those on the active layer. (b) The Layers palette shows the position of the Photo Filter layer that was blended with the underlying black-and-white image layer.

right of the white slider will not be visible; instead, pixels from underlying visible layers will show through in those areas. Pixels with values between the black and white sliders will be blended with pixels in the underlying layers to create composite pixels according to the blending mode of the active layer. The transition between blended and unblended pixels can be smoothed by pressing Option/Alt and dragging on a slider to split it, then dragging the two halves of the slider to specify a range for partially blended pixels. In contrast, the Underlying Layer sliders specify which pixels in the underlying layers will appear in the final image. Pixels with values to the left of the black Underlying Layer slider or to the right of the white Underlying Layer slider will show through the active layer without being blended. Pixels between the black and white sliders will be blended with pixels in the active layer to create composite pixels. The Underlying Layer sliders can also be split to smooth the transition between blended and unblended pixels.

To apply this technique to limit toning of an image, position the toned image layer or toning adjustment layer above the black-and-white image layer (fig. 5-16b) and open the Layer Style dialog box for the toning layer. Toning can be applied selectively to shadows and midtones by dragging the white Underlying Layer slider to the left, which will exclude all pixel values to the right of that slider from toning. Split the white slider and drag the two halves of the slider to establish a transition range for partially blended pixels between blended and unblended pixels. To limit toning in the shadows, drag the black Underlying Layer slider to the right and split the slider to establish a transitional blending zone. Ad-

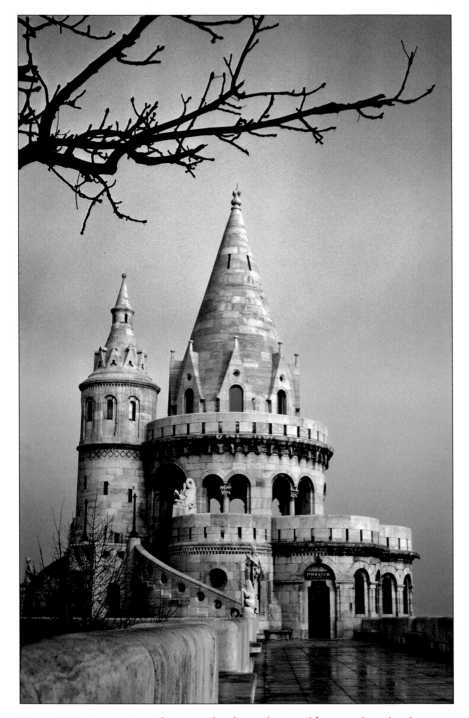

FIGURE 5-17. BLENDED TINT. Blue toning has been eliminated from pixels with values over 209 and decreased for pixels with values from 134 to 209 by applying the settings shown in figure 5-16a.

vanced blending settings were applied to the Photo Filter adjustment layer that toned the Fishermen's Bastion image (fig. 5-10c) to eliminate toning from pixels with values greater than 209, as seen in figure 5-17.

□ SELECTION TO LIMIT COLORIZATION

Another method to limit the tonal values colorized utilizes a mask applied to a tinting layer, such as a Color Fill (Solid Color), Photo Filter, or Average Color layer. To selectively tone the shadows and midtones of a black-and-white image using a Color Fill adjustment layer, press Command/Control and click on the composite RGB channel at the top of the Channels palette. This loads a selection based upon the luminosity of the image. Choose Select>Inverse to create an inverse selection. Press Q to view this selection as an inverted luminosity mask. To make it easier to differentiate the selected from the unselected areas, double-click on the Quick Mask mode icon in the Toolbox to open the Quick Mask Options dialog box. Set the Color Indicates option to Selected Areas and the Color Opacity to 100%, then click OK. To more clearly separate the highlights from the shadows, apply a Levels adjustment to the Quick Mask by pressing Command/Control+L. Now move the white Input Levels slider to the left until the pink tone disappears from the highlights you want to protect from toning. An example of an inverted luminosity mask is shown in figure 5-18a, where the shadows are displayed with a rubicon (red) mask. Type Q again to return to the selection.

Click on the half-black/half-white circle icon at the base of the Layers palette and select Solid Color adjustment layer from the pop-up menu. From the Color Picker dialog box, choose a warm or cool color to tone the image and click OK (fig. 5-18b). Since the inverted luminosity selection was active when the adjustment layer was added, the selection was converted into a mask for the layer (fig. 5-18c). Change the blending mode of the layer from Normal to Color, then adjust the opacity of the layer accord-

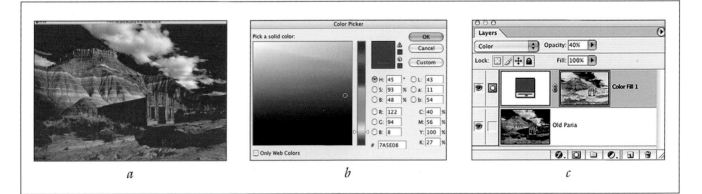

a　　　　　*b*　　　　　*c*

FIGURES 5-18A, B, AND C. MASKED COLOR FILL. (a) An inverted luminosity mask enhanced with a Levels adjustment displays shadows in red and highlights in white. (b) The Color Picker dialog box shows the color selected for the Color Fill adjustment layer. (c) The Layers palette depicts the Color Fill adjustment layer with an inverted luminosity mask overlying the black-and-white image layer. The blending mode of the Color Fill layer has been changed to Color and its opacity reduced to 40%.

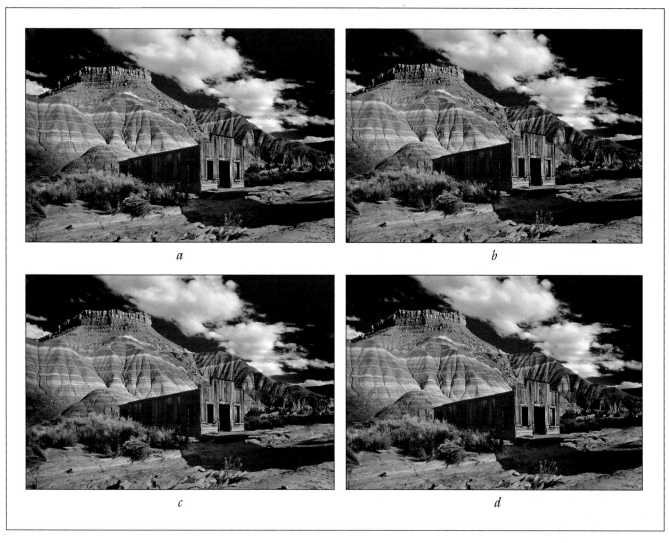

FIGURES 5-19A, B, C, AND D. MASKED COLOR FILL, SEPIA. (a) Black-and-white image, converted from Velvia. (b) Toning of image with Color Fill adjustment layer settings as depicted in figure 5-18b. (c) Selective toning of shadows with Color Fill adjustment layer through inverted luminosity mask. (d) Selective toning of highlights with Color Fill adjustment layer through luminosity mask.

ing to personal preference to make the toning subtle or more obvious. The toning applied by the Color Fill adjustment layer to the Paria image appears very different when modulated by an inverted luminosity mask (figs. 5-19a–c). Other layer blending modes, including Overlay, Soft Light, Hard Light, or Multiply, can also be tried to vary the effect.

A similar approach can be utilized to tone the highlights selectively. Press Command/Control and click on the RGB channel at the top of the Channels palette to load a selection based upon luminosity. Press Q to enter Quick Mask mode, edit this mask using a Levels adjustment as described for the inverted luminosity selection, and press Q again to return to the luminosity selection. With this selection active, add a Solid Color adjustment layer and change its blending mode to Color. Adjust the layer opacity to achieve the desired toning effect. I applied this masking technique to add density to the highlights in figure 5-19d.

☐ SPLIT TONES

In the traditional darkroom, a split-tone print is a black-and-white print that has been partially toned or had a mix of toning effects applied. In the digital darkroom, this effect can be simulated by blending two layers with different tones using blending sliders. To apply a split-tone effect in the

digital darkroom, select the black-and-white image layer, then add a Color Balance adjustment layer to colorize the image. Alternative colorizing modes that can be used include a Hue/Saturation adjustment layer with the Colorize box checked or a Channel Mixer adjustment layer with the Monochrome box unchecked. Adjust the Color Balance sliders for the shadows and midtones to produce the desired base layer tone. The settings shown in figures 5-20a and 5-20b for the shadows and midtones yield a sepia tone. Now add another Color Balance adjustment layer above this one (fig. 5-21). Adjust the Color Balance sliders for the midtones and highlights to find a color that contrasts with the base layer tone. The settings depicted for the midtones and highlights in figures 5-20c and 5-20d produce a cyan tone. To blend the shadow and highlight tones in these layers, double-click on the right side of the upper Color Balance layer (cyan in this example) to open the Layer Style dialog box. Within the Advanced Blending section, move the This Layer black slider to the right to allow pixels with lower values to show through from the underlying layers (fig. 5-22). Press Option/Alt and drag the black slider to split it, then pull the right half of the slider to the right to establish the upper value for partially blended pixels; pixels with values higher than this will be

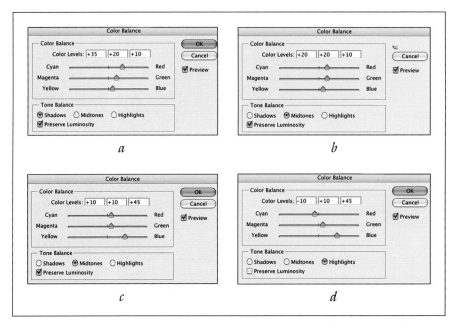

FIGURES 5-20A, B, C, AND D. COLOR BALANCE SETTINGS. (a) Shadows settings for lower Color Balance layer. (b) Midtones settings for lower Color Balance layer. (c) Midtones settings for the upper Color Balance layer. (d) Highlights settings for upper Color Balance layer. For the upper Color Balance layer, the Preserve Luminosity setting was not chosen because this option imparted an overly bright cyan tone to the image highlights.

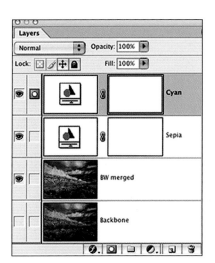

FIGURE 5-21. LAYERS PALETTE FOR SPLIT-TONE IMAGE. Color Balance layers named sepia and cyan are positioned above the black-and-white image derived from a multilayer conversion.

FIGURE 5-22. CYAN LAYER STYLE BLENDING OPTIONS. These blending settings for the cyan layer were applied to derive a split-tone sepia–cyan image.

blended. Thus, in this example, pixels with values less than 76 are derived only from the underlying layers, pixels with values from 76 to 243 are partially blended, and pixels with values greater than 243 are blended between the layers. The split-tone image, shown in figure 5-23, is characterized by sepia in the shadows that blends with cyan in the highlights.

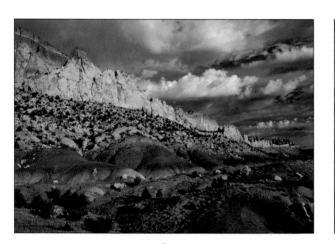

a

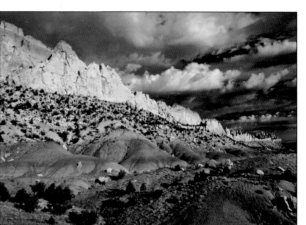

b

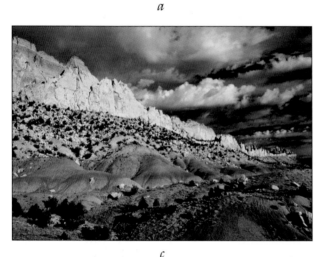

c

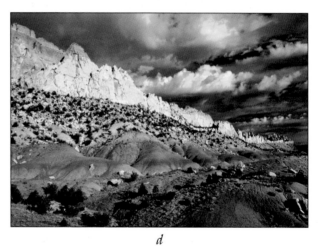

d

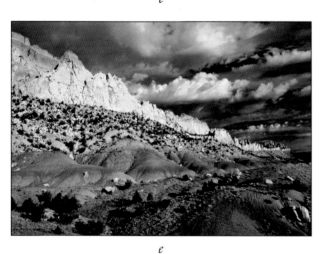

e

FIGURES 5-23A, B, C, D, AND E. STEPS TO SPLIT-TONE IMAGE. (a) Original Velvia image, Grand Staircase. (b) Black-and-white image created using multilayer decolorizing technique. (c) Sepia image. (d) Cyan image. (e) Split-tone sepia—cyan image.

☐ **GRADIENT MAP**

A Gradient Map (Image>Adjustments>Gradient Map) allows one to create an interesting colorizing effect by replacing the luminosity values in an image with the colors in a gradient. The shadows are replaced by the color on the left side of the gradient and the highlights by the color on the right. This command was described in the previous chapter as a means of converting an image to black and white by using a Black, White gradient.

Open or create a black-and-white image. Click on the half-black/half-white circle icon at the bottom of the Layers palette, then select Gradient Map from the menu. This opens the Gradient Map dialog box, which by default shows a Foreground-to-Background gradient (fig. 5-24a). Select the Preview option and click on the gradient to open the Gradient Editor dialog box (fig. 5-24b). Now choose one of the preset gradients in the upper section or create your own in the bottom section. To make a custom gradient, click on the left color stop to define a starting

TO MAKE A CUSTOM GRADIENT, CLICK ON THE LEFT COLOR STOP TO DEFINE A STARTING COLOR AND THE RIGHT COLOR STOP TO SET AN ENDING COLOR.

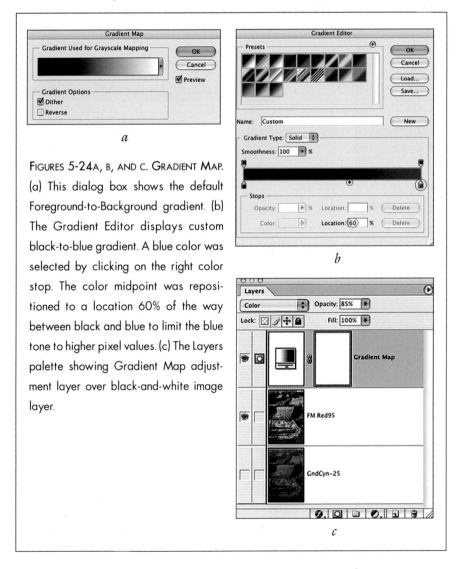

FIGURES 5-24A, B, AND C. GRADIENT MAP. (a) This dialog box shows the default Foreground-to-Background gradient. (b) The Gradient Editor displays custom black-to-blue gradient. A blue color was selected by clicking on the right color stop. The color midpoint was repositioned to a location 60% of the way between black and blue to limit the blue tone to higher pixel values. (c) The Layers palette showing Gradient Map adjustment layer over black-and-white image layer.

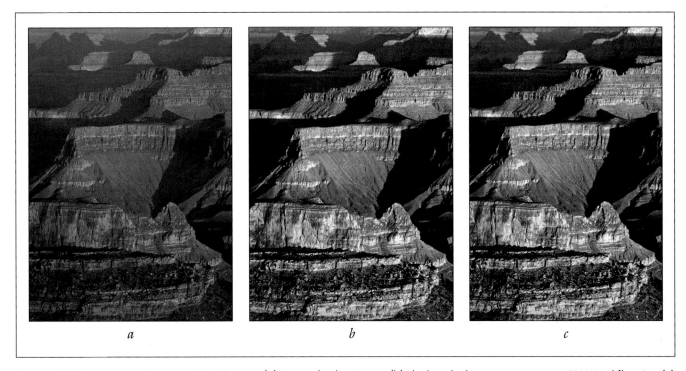

a b c

FIGURES 5-25A, B, AND C. GRADIENT MAP TONING. (a) Original Velvia Image. (b) Black-and-white conversion using BW Workflow Pro. (c) Gradient Map toning with black in the shadows and blue in the highlights.

color and the right color stop to set an ending color. I chose a black-to-blue gradient. Additional color stops can be added by clicking along the lower margin of the gradient. The color stops and intermediate color midpoints can be moved to the right or left to modify the gradient. I moved the color midpoint to the right to location 60%. For additional control, the opacity of the gradient can be modified at any point by clicking on the opacity stops on the upper border of the gradient. Click OK to close the Gradient Editor. In the Gradient Map dialog box, check the Dither box under Gradient Options and click OK to apply the gradient to the image. Experiment by changing the blending mode of the Gradient Map layer to Color or Soft Light and varying the layer opacity. I selected the Color blending mode and decreased the layer opacity to 85% (fig. 5-24c) to yield the blue toning effect in figure 5-25. In this image, the shadows and most midtones are mapped to black and the upper midtones and highlights are mapped to blue. An alternative, though less instructive, way to add a Gradient Map adjustment layer is to run the Photoshop action Gradient Map, found in the Image Effects actions.

☐ DUOTONES

Duotones combine two inks of different colors to extend the tonal range of a grayscale image. This concept can be extended to tritones and quadtones, representing combinations of three and four different inks, respectively. Although a grayscale reproduction can display up to 256 tones of gray (8-bits/channel mode), a printing press can reproduce only about 50

FIGURE 5-26. LAB MODE FOR GRAYSCALE CONVERSION. Following conversion of the image to Lab mode, the Lightness channel is selected from the Channels palette. Convert the image to Grayscale to discard the a and b color channels.

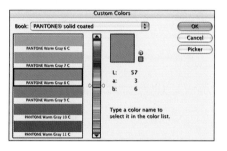

FIGURE 5-27. DUOTONE OPTIONS MENU.

FIGURE 5-28. CUSTOM COLORS. Access the Color Picker or Custom Colors options by clicking on the ink color square in the Duotone Options dialog box.

tones of gray per ink. Consequently, by using two to four inks, the tonal range can be increased to 100 to 200 levels of gray. Duotones may be printed using black ink for shadows and gray ink for midtones and highlights, but more often a colored ink is chosen for the midtones and highlights. Thus, duotones usually tint the image, typically applying color to the shadows and midtones without "washing over" the highlights.

Prior to conversion to Duotone mode, an image must be in Grayscale mode. The usual approach is to convert an RGB image to Grayscale mode (Image>Mode>Grayscale). However, a better duotone may sometimes be created by first converting the image to Lab Color (Image>Mode>Lab Color), then selecting the Lightness channel and converting the image to Grayscale (fig. 5-26). To convert the Grayscale image to Duotone mode, choose the menu item Image>Mode>Duotone. From the Duotone Options dialog box, select the type of duotone: Monotone, Duotone, Tritone, or Quadtone (fig. 5-27). Make sure the Preview box is checked. Choose a color for each ink by clicking on the respective ink color square to open the Color Picker or Custom Colors dialog box (depending upon the type of color in the color square). The Custom Colors dialog box is depicted in figure 5-28. Within Duotone Options, place the darker ink at the top and the lighter ink at the bottom to reproduce the color saturation

DUOTONES USUALLY TINT THE IMAGE, TYPICALLY APPLYING COLOR TO THE SHADOWS AND MIDTONES WITHOUT "WASHING OVER" THE HIGHLIGHTS.

as accurately as possible. Click on the curve box next to the ink color square to view the curve that controls how the tint value of the selected color (y-axis) correlates with the shades of gray in the image (x-axis; fig. 5-29). Pull the curve down to lighten the image or up to darken it. To select the colors and curves from preconfigured duotones, tritones, or quadtones, click the Load button. Choosing the duotone called Warm Gray 8 bl 4 from the Gray/Black Duotones folder yields the duotone colors and curves shown in figure 5-30a. Applied to the grayscale image of St. Stephen, these settings produced the warm image in figure 5-31. For comparison, I also

TO SELECT THE COLORS AND CURVES FROM PRECONFIGURED DUOTONES, TRITONES, OR QUADTONES, CLICK THE LOAD BUTTON.

selected the quadtones depicted in figure 5-30b to apply a selenium tone to the same image. Experiment with other preconfigured quadtones, such as the Gray Quadtones Bl CG10 CG4 WmG3 and Bl CG10 WmG3 CG1 and the PantoneQuadtone Bl 541 513 5773.

Photoshop does not show the individual color channels for duotone images but instead manages them as single-channel, 8-bit, grayscale images. Consequently, the channels must be adjusted via the ink curves in the Duotone Options dialog box (Image>Mode>Duotone). To see each color channel as it will appear after the curves are applied, convert to Multichannel mode (Image>Mode>Multichannel). For a duotone, the Channels palette will show Channel 1 for Ink 1 and Channel 2 for Ink 2. The channels cannot be edited in this mode if they are going to be converted back to Duotone mode.

To print the image with Pantone or other custom spot colors, save the Duotone image file in Photoshop EPS format, including the Transfer Function but not the Halftone Screen (unless you have specified the screens and frequencies under File>Page Setup). Photoshop will then create an EPS file with duotone plates for the image setter. The same black-and-white channel will be applied to each of the duo-

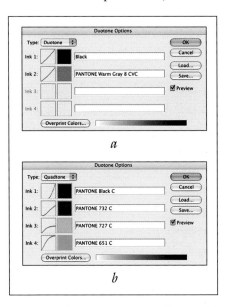

a

b

FIGURES 5-30A AND B. DUOTONE COLORS. (a) These duotone colors apply a slightly warm tone to the image. (b) These quadtone colors yield a cool image with a deep purplish cast reminiscent of selenium toning.

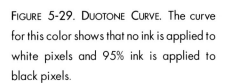

FIGURE 5-29. DUOTONE CURVE. The curve for this color shows that no ink is applied to white pixels and 95% ink is applied to black pixels.

tone colors, using the appropriate curve for that color as specified in the Duotone Options dialog box. A good simulation of a duotone print can be achieved using the CMYK printing process (Image>Mode>CMYK Color). To print a duotone from an RGB device, convert it to RGB Color (Image>Mode>RGB Color). This allows one to simulate the tonal range of duotones using an inkjet printer.

□ PAINTING WITH COLOR LAYERS

Rather than applying a uniform tone to an entire image, the appearance of an old-fashioned, hand-tinted black-and-white print can be produced by painting on one or more layers above a grayscale image layer. A variation on this technique is to paint only selected portions of the image to focus attention on those elements. To utilize this method, start with a black-and-white image and click on the Create a New Layer icon at the bottom of the Layers palette. Change the blending mode of the new layer from Normal to Color using the pop-up menu at the top of the Layers palette, then choose a brush (B, Shift+B) of the appropriate size for

FIGURES 5-31A, B, C, AND D. DUOTONES. (a) Original Kodachrome image. (b) Black-and-white conversion to grayscale via Lab mode. (c) Warm duotone created using settings shown in figure 5-30a. (d) Cool duotone (quadtone) created using settings depicted in figure 5-30b.

the object to be painted and select a color from the color selection box in the Toolbox. The strength of the color can be varied by adjusting the opacity of the brush in the Brush Options bar or the opacity of the layer. To maintain maximum flexibility for subsequent adjustments, I recommend adding a new layer for each color, as shown in figure 5-32. Since this may lead to complex configurations with multiple layers, each layer should be named with the color and/or object painted to simplify subsequent modifications. The result of painting with magenta, green, and yellow on separate layers over a black-and-white image layer is demonstrated in figure 5-33. The blending mode of each layer has been changed to Color, and the opacity of each layer has been adjusted to yield the final effect.

FIGURE 5-32. PAINTING WITH COLOR LAYERS. The Layers palette shows the layers configuration for this effect. The blending mode of the Magenta layer is Color and the opacity 50%. The opacity could be decreased for a more subtle effect.

FIGURES 5-33A, B, C, AND D. PAINTING WITH COLOR. (a) Original Velvia image. (b) Black-and-white conversion using B/W Converter. (c) Composite of painted layers applied to black-and-white image in Color mode. (d) The composite painted image shows more contemporary lipstick.

☐ TINTING WITH SELECTIONS

With this technique, selections within a grayscale image are colorized by using a different Color Fill or Hue/Saturation adjustment layer for each color. The effect is similar to that achieved with the Painting in Color method described above, but this approach uses a selection to target an area for tinting with a given color (fig. 5-34). Starting with a color image

of California poppies (fig. 5-35a), I converted the image to black and white (fig. 5-35b) on a new layer above the color image layer. To select the central poppy, I used the Magic Wand on the color image. Then I added a Color Fill (Solid Color) adjustment layer filled with a golden color above the black-and-white image layer. Because the selection was active when the adjustment layer was added, the color was applied selectively to the poppy through the layer mask. I experimented with several layer blending modes, including Color, Soft Light, and Overlay, but chose Hard Light because it provided the best color fill for this image. To reduce the intensity of the color, I decreased the opacity of the layer to 65% (fig. 5-35c). This yielded a nice image, but I felt that the white tone of the background poppies drew attention away from the central subject. To select a color to tone the background poppies, I could have added another Color Fill adjustment layer. Instead, I clicked on the Create a New Layer icon at the bottom of the Layers palette to add a new layer above the Color Fill layer. To change the foreground color, I clicked on the upper color selection box in the Toolbox and chose blue (the color complementary to yellow) from the Color Picker. Then I pressed the Option/Alt+Delete/Backspace keys to fill the new layer with this color. For a subtle toning effect, I decreased the layer opacity to 15% with Color blending mode.

FIGURE 5-34. TINTING WITH SELECTIONS LAYERS. Layers palette shows masked Color Fill layer that imparts golden color to poppy using Hard Light blending mode with reduced layer opacity. The layer at the top of the stack is filled with blue in Color blending mode with layer opacity 15%, adding a subtle bluish cast to the image.

a

b

c

FIGURES 5-35A, B, AND C. TINTING WITH SELECTIONS. (a) Original Velvia image. (b) Black-and-white conversion using B/W Converter. (c) Golden color selectively reintroduced to poppy via a layer mask.

Tinting can also be applied to an object by painting on a layer mask that hides the effect of the Color Fill or Hue/Saturation adjustment layer. To use this approach, add a Color Fill adjustment layer in Color blending mode or a Hue/Saturation adjustment layer with the Colorize box checked for each desired color, then hide the effect of each layer by inverting its layer mask from white to black (Command/Control+I). Select a brush (B, Shift+B) of the appropriate size for the object to be colorized and paint in white on each mask to reveal elements in that color. To decrease the intensity of the color, paint with a shade of gray rather than white or decrease the opacity of the layer. In addition, the blending mode of each layer can be modified to produce a different effect for each color. This method yields results identical to tinting with selections.

☐ COLORIZING LAYER MASK

An image can also be selectively colorized by painting on a layer mask to reveal color from an underlying layer. This differs from the previous methods in that color is being introduced from the original image. Start with a black-and-white image layer above the color image layer. If not already present, add a mask to the black-and-white layer by highlighting the layer and clicking on the Add Layer Mask icon. Click on this mask, then select the Brush tool (B, Shift+B) and paint with black or gray to show color from the image below. By decreasing the opacity of the Brush tool, subtle effects can be achieved.

> AN IMAGE CAN ALSO BE SELECTIVELY COLORIZED BY PAINTING ON A LAYER MASK TO REVEAL COLOR FROM AN UNDERLYING LAYER.

As an alternative, color can be restored to the central portion of an image. Select the Gradient tool (G, Shift+G) and choose a black–white radial gradient from the Options bar. Click on the mask for the black-and-white layer and position the cursor over the center of the area to be colorized. Drag from that point outward to apply the gradient to the mask. You may need to apply the gradient several times to achieve the desired effect. To restore color to an elliptical area in the center of the image, click on the mask for the black-and-white layer, then select the elliptical Marquee tool (M, Shift+M) and drag over the image to create an elliptical selection of the desired size and position. Set the foreground color to black, then press Option/Alt+Delete/Backspace to fill the selected area with black. Press Command/Control+D to deselect the selection. Soften the edges of the mask by applying a

FIGURE 5-36. COLORIZING LAYER MASK. The Layers palette shows a black-and-white image overlying the color image. The black portion of the layer mask allows color to show through the central part of the image.

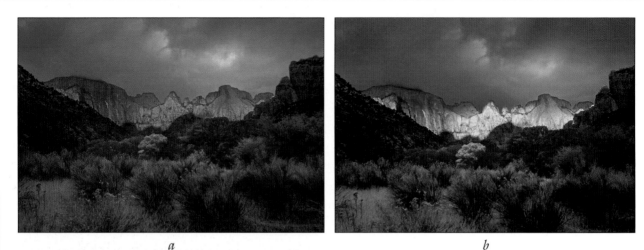

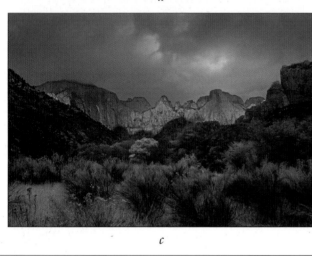

FIGURE 5-37A, B, AND C. CENTRAL COLOR. (a) Original Velvia image, Towers of the Virgin. (b) Black-and-white conversion using B/W Converter. (c) Image after application of elliptical mask to allow color to show through the center of the black-and-white image.

Gaussian blur (Filter>Blur>Gaussian Blur). Figure 5-36 shows the configuration of the Layers palette for this technique, with an elliptical mask blocking the black-and-white effect in the central portion of figure 5-37.

☐ THIRD-PARTY FILTERS

nik Color Efex Pro 2. This product contains a number of filters other than those that convert color images to black and white. The Colorize filter tints an image any color desired, including sepia. The Duplex Monochrome filter produces a traditional duplex or duotone effect by blending black with one additional color. A magenta color was applied to the orchid seen in the filter preview box in figure 5-38. The Paper Toner filters apply several toning effects, including sepia tones, and are perhaps the most useful of the filters for simulating traditional toning effects (fig. 5-39). Other filters applicable to black-and-white images include Ink, the Photo Styler set (Cool Ice, Cool Silver [fig. 5-40], Copper, Russett, and Varitone), and Midnight Sepia (which incorporates a blur for a dreamy effect).

Pixel Genius Photo Kit. In addition to the black-and-white conversion options discussed in chapter 4, Photo Kit includes a B&W Toning set that includes several strengths of Sepia and Cold tones, Selenium tone, Plat-

FIGURE 5-38. NIK COLOR EFEX PRO 2: DUPLEX MONOCHROME FILTER.

inum tone, and Brown tone. These filters work with either color or black-and-white images. This toning set should be of particular interest to persons who do not have access to Color Efex Pro or a similar set of filters.

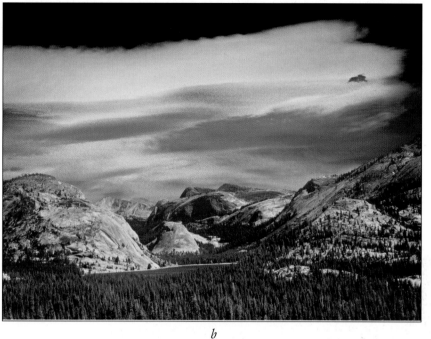

FIGURES 5-39A AND B. NIK COLOR EFEX PRO 2: PAPER TONER FILTER. (a) Settings for Paper Tone and Strength. (b) Cool cast over Tenaya Lake after application of Paper Toner filter.

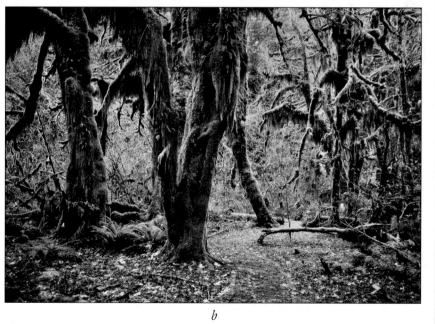

FIGURES 5-40A AND B. NIK COLOR EFEX PRO 2: PHOTO STYLER COOL SILVER. (a) Dialog box offers choice of Style and Strength. (b) Cool cast over rain forest after applying Cool Silver filter.

Photoshop. This chapter explores these and other tools that expand our ability to create fine-art prints.

■ INFRARED EFFECT

Luminous black-and-white images can be created using film or a digital chip sensitive to infrared rather than the visible spectrum. Within the infrared spectrum, trees and plants seem to glow, clouds are bright, and skies are dark. To simulate this effect in the digital darkroom with a color image, add a Channel Mixer adjustment layer and check the Monochrome box (fig. 6-1). Since vegetation records brightly with infrared film, the green channel percentage should be set relatively high—start with 190%. To keep the sum of the individual color channel percentages near 100%, the blue and red channels will need to be significantly negative. Set the red channel to –50% and the blue channel to –30% (fig. 6-2). Depending upon the image, these percentages may need to be modified to achieve an infrared look. For many images, an infrared appearance is best achieved when the percentages total more than 100%.

Since infrared images tend to have a soft, ethereal feeling, some

FIGURE 6-1. LAYERS PALETTE, INFRARED EFFECT. Blur, Diffuse Glow, and grain are applied to the color image, which is converted to black and white by the Channel Mixer adjustment layer.

FIGURE 6-2. CHANNEL MIXER SETTINGS, INFRARED EFFECT.

FIGURE 6-3. FADE OPTIONS. After blurring the green channel, change the blending mode in this box to Screen and adjust the opacity if needed. This dialog box is available only as the next step after the filter is applied.

FIGURE 6-4. DIFFUSE GLOW OPTIONS. The Fade command can also be used to modify the effect of this filter.

FIGURE 6-5. ADD NOISE OPTIONS. To avoid altering image pixels, apply this filter to a separate layer in Overlay blending mode.

blur should be introduced into the image. Duplicate the image layer (Command/Control+J) and name it "Blur," then, with this layer highlighted, select the Green channel in the Channels palette. To make all channels visible, click the empty box to the left of the RGB channel thumbnail so the eyeball icon appears. Make sure the RGB channel is not highlighted, so the changes will affect only the Green channel. Next apply a Gaussian blur (Filter>Blur>Gaussian Blur) to this channel. Start with Radius of 2 to 5 pixels and adjust to achieve a pleasing visual effect. Before performing any other operations in Photoshop, go to Edit>Fade Gaussian Blur. The Fade dialog box offers options for Mode and Opacity (fig. 6-3). Change the blending mode from Normal to Screen to produce brightness in the Green channel, then decrease the opacity if the effect is excessive. Now click on the RGB channel (not the eye icon) to select all color channels.

Because infrared film is characterized by bright highlights and a grainy appearance, the effect can be heightened by applying a Diffuse Glow filter. Duplicate the Blur layer (Command/Control+J) and name this new layer "Diffuse Glow." Next select the menu item Filter> Distort>Diffuse Glow. In the dialog box, specify Graininess, Glow Amount, and Clear Amount; I selected a value of 10 for each parameter (fig. 6-4). For an exaggerated effect, press Command/ Control+F to apply the Diffuse Glow filter again with the same settings. To reduce the strength of the filter, use the Edit>Fade Diffuse Glow command or decrease the opacity of the Diffuse Glow layer.

To enhance the graininess of the image, additional noise can be added. While pressing on the Option/Alt key, click on the Create a New Layer icon at the bottom of the Layers palette. In the New Layer dialog box, name the layer "Grain" and select the Overlay blending mode, filled with Overlay-neutral color (50% gray). From the menu select Filter>Noise>Add Noise. Viewing the image at 100%, choose Gaussian distribution (which resembles film grain more than Uniform), check the Monochromatic box, and select an amount of noise that appears realistic—this number will vary depending upon the file size but will usually be relatively small (fig. 6-5).

The components of the infrared effect can now be independently adjusted by varying the opacity of the Blur, Diffuse Glow, and Grain layers and fine-tuning the color channel blend in the Channel Mixer. The appearance

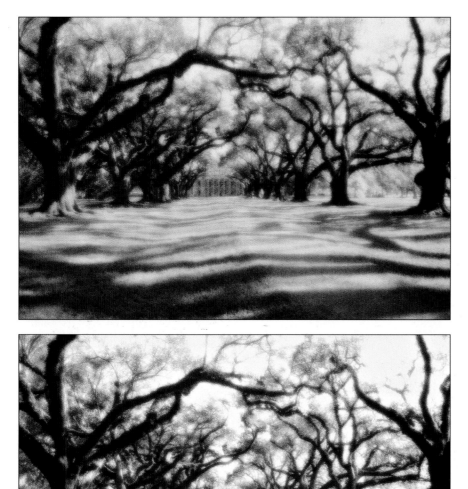

of a color image of ancient oaks after application of blur, the Diffuse Glow filter, and noise is shown in figure 6-6a. After additional processing by the Channel Mixer, the glowing infrared effect depicted in figure 6-6b was achieved. For this image, I selectively burned elements in the image and added a Curves adjustment layer to increase the contrast slightly.

An alternative infrared technique utilizes the nik Color Efex Pro 2: Infrared BW Filter. This filter emulates conventional black-and-white infrared film and can be applied to a color or black-and-white image. Several different effects are possible, depending upon the settings for Highlights, Brightness, and Contrast (fig. 6-7). Starting with a color image, I first applied the B/W Converter Tonal Enhancer filter and then the nik Infrared BW filter. As illustrated in figure 6-8, the infrared rendering produced by this filter tends to be more conservative than the previous technique.

For a more ethereal infrared rendering, additional blur and noise can be applied.

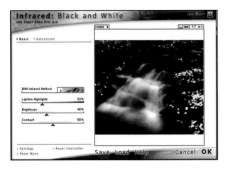

FIGURE 6-7. NIK COLOR EFEX PRO 2: INFRARED BLACK AND WHITE FILTER SETTINGS.

□ HIGH-CONTRAST EFFECT

A very dramatic image can be created using a Threshold adjustment layer to convert a color or grayscale image into black-and-white without any intermediate tones. Create a Threshold adjustment layer by clicking the half-black/half-white circle icon at the bottom of the Layers palette and choosing Threshold from the pop-up menu. The default Threshold Level setting of 128 shows all values less than 128 as black and all values greater than 128 as white. Change the threshold value by moving the slider back and forth to see which setting yields the best black-and-white effect, then click OK. To apply this technique, I started with a black-and-white image

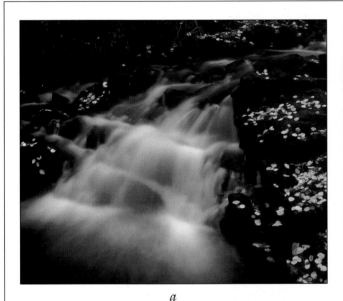

a

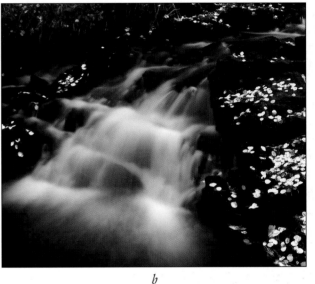

b

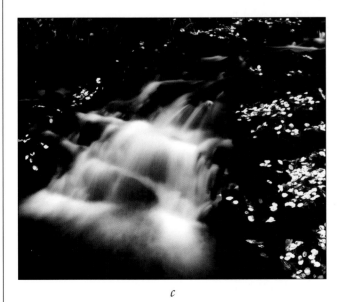

c

FIGURES 6-8A, B, AND C. INFRARED SIMULATION. (a) Original Velvia image, Sierra Cascade. (b) Black-and-white conversion using B/W Converter. (c) Image after application of the nik Infrared Black and White filter.

of a rain forest (fig. 5-40b). I then added a Threshold adjustment layer with Threshold Level 128. This created a stark black-and-white image reminiscent of a pen and ink drawing, as seen in figure 6-9. The fine detail in this image contributes to the effective application of this high-contrast effect.

☐ HIGH-KEY EFFECT

High-fashion photographers overexpose film to create images with very light skin tones and increased shadow detail. Some photographers also overexpose objects in nature to create a similar artistic effect. This technique, known as high-key, is characterized by an emphasis on highlights with few midtones and fewer darker tones.

To reproduce this effect in the digital darkroom, identify the brightest area in a black-and-white image using a Threshold adjustment layer. Click on the half-black/half-white circle icon to add a new adjustment layer and select Threshold from the menu. The Threshold dialog box will open with the Threshold Level set at 128. Move the slider all the way to the right, and then slowly back to the left until you notice an area of white appearing against the black background—this represents the highlight. To mark this point with the Color Sampler, press the Shift key and click on the highlight. Close the Threshold adjustment layer without keeping any changes. A circular target with the number 1 (or a higher number if other Color Sampler points were previously placed) now appears over the highlight, and the Info palette displays the corresponding RGB or Grayscale values for that point.

In the black-and-white rendering of the orchid in figure 6-10, several areas around the center of the flower were equally bright with RGB value 246. Although this is close to the final highlight value desired for a high-

key image, the overall lightness of this image was insufficient to produce the effect. Consequently, I added a Curves adjustment layer and pulled the right end of the curve down until the highlight RGB value was about 210, then I pulled the middle of the curve down a bit more to increase the contrast in the higher tones (fig. 6-10b). Although this highlight adjustment is not usually necessary, it may improve the result if the initial image highlight is similarly bright. After checking and, if needed, adjusting the highlight, apply the following steps to produce the high-key effect.

Click on the Create a New Set icon at the bottom of the Layers palette and name the set "High Key" (fig. 6-11). Now add a new Curves adjustment layer and click OK in the dialog box without modifying the curve. This adjustment layer should appear in the High Key layer set. Change the blending mode of this layer from Normal to Screen, which simulates overexposing the image by about two stops, then decrease the magnitude of this effect by reducing the opacity of the layer from 100% down to 10 to 15%. To create the high-key look, duplicate the Curves adjustment layer (Command/Control+J) as many times as necessary to reach highlight values around RGB 246 as displayed in the Info palette for the Color Sampler

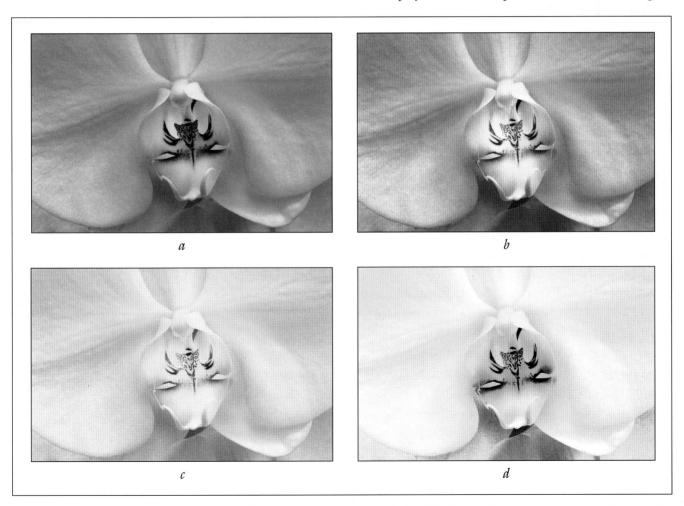

a

b

c

d

FIGURES 6-10A, B, C, AND D. HIGH-KEY EFFECT. (a) Original Velvia image, Cymbidium. (b) Black-and-white conversion. (c) Lightened orchid after applying high-key effect. (d) Enhanced effect created with Vivid Light blending mode.

point. With the orchid image, I set the opacity of each of these layers to 15% and reached a highlight value of 246 after duplicating the Curves layer 10 times. The brightness of the highlight in this image is the same after these adjustments as initially, but the overall appearance is quite different (fig. 6-10c). The trick is to add multiple Curves adjustment layers that incrementally lighten the image—this creates an overall lighter image than making the adjustment in a single step. The amount of overexposure can now be adjusted. To lessen the high-key effect, decrease the opacity of the High Key layer set. To limit the areas of the image affected, add a layer mask to the High Key layer set, invert the mask (Command/Control+I) so it hides the High Key set, then paint on the mask with white to reveal high-key areas. Depending upon the desired mood, adding blur, noise, or different blending modes may enhance the overall appearance.

I utilized Vivid Light blending mode to create a more dramatic image. First, I duplicated the high-key image (Image>Duplicate). Then I merged the black-and-white image layer and the High Key adjustment layers into a single high-key black-and-white layer above the original color image. I duplicated this merged layer, changed the blending mode of the new layer to Vivid Light, and decreased the opacity of the new layer to 65%. Then I added a mask to the bottom black-and-white image layer (immediately above the color image) and painted on the mask with a black brush at low opacity to bring back more detail from the center of the flower. This also returned some color to the center of the image, which I removed with a Hue/Saturation adjustment layer. Lastly, I used a Curves adjustment layer to increase contrast in the center of the flower. The resultant image is shown in figure 6-10d. It has a soft, high-key feel with an intriguing pattern.

□ LENS EFFECTS

Soft Focus. A classic photographic technique to capture a dreamlike feeling or remove blemishes from the skin is to blur the focus of the subject. Traditionally, this has been accomplished by using a special soft-focus lens, placing gauze over a camera lens, or even rubbing a thin coating of petroleum jelly over a filter covering the lens. In Photoshop, we can reproduce this effect with greater creativity by blending a blurred copy of an image with the original.

Duplicate the background black-and-white image layer (Command/Control+J) so the filter is not applied to the original image pixels and name the new layer "Blur." Now select Filter>Blur>Gaussian Blur and apply a radius of 25 pixels. Decrease the opacity of the blurred layer to around 50% and adjust it according to personal preference (fig. 6-12). Add a layer mask to the Blur layer and paint with black or shades of gray on the mask to decrease the soft focus effect selectively within the image. This soft-focus technique was applied to the flower in figure 6-13a, and the central portion of the Blur layer mask was painted with black to maintain image sharpness in that area.

FIGURE 6-11. LAYERS PALETTE, HIGH-KEY EFFECT. The black-and-white image was darkened as described in the text, then multiple adjustment layers in Screen blending mode at low opacity were added within the High Key set.

FIGURE 6-12. LAYERS PALETTE, SOFT FOCUS. The black-and-white image layer was duplicated as the blur layer, and a Gaussian Blur filter with radius 25 was applied. The opacity of the blur layer was decreased to 50%, and a layer mask was added that blocks the central area of the flower from the blurring effect.

a

b

c

FIGURES 6-13A, B, AND C. SOFT FOCUS. (a) Gaussian Blur with parameters as described in figure 6-12. (b) Gaussian Blur with radius 25%, layer blending mode set to Lighten, and layer opacity 100%. (c) Blurred image layer in Lighten mode blended with original color image rather than black-and-white image.

The brighter image pixels can be emphasized by changing the blending mode of the Blur layer from Normal to Lighten or Screen and increasing the layer opacity. This produces a soft glow that can be very appealing, as shown in figure 6-13b, where the blending mode of the Blur layer was changed to Lighten and its opacity was increased to 100%. To create a soft blending effect that restores some color to the image, place the Blur layer in Lighten blending mode above the original color image, rather than the black-and-white image. For this particular image, applying this blending technique added an opalescent quality (fig. 6-13c).

The amount of blur can be varied as a function of image tonality by specifying tonal ranges for blending. Double-click on the blurred image thumbnail to open the Layer Style dialog box. Adjust the sliders in the This Layer section at the bottom of the Blending Options dialog box to exclude shadows and/or highlights from the blur effect. Split one or both sliders to blend the transition between blurred and non-blurred pixels by pressing Option/Alt and dragging on the slider. For example, the settings in figure 6-14 indicate that highlights with values over 200 will not be blurred, pixels with values between 125 and 200 will be partially blended between the blurred and non-blurred layers, and pixels with values under 125 will be

FIGURE 6-14. LAYER STYLE BLENDING OPTIONS. The This Layer blending settings decrease blurring of the lighter pixels.

FIGURE 6-15. SOFT FOCUS BY TONAL RANGE. The lighter pixels in the image are excluded from the soft focus effect. Compare to figure 6-13b.

blended between the blurred and non-blurred layers. Applied to the Blur layer of the flower in figure 6-13b, these layer blending settings maintain the sharpness of the features with lighter tones, as shown in figure 6-15.

Selective Focus. Selective focus can be used to draw attention to the center of interest while blurring the surroundings. When photographing a subject, a large lens aperture with limited depth of field is utilized to produce this effect. To create this appearance in the digital darkroom, a soft focus blur can be selectively applied to the image, as described in the Depth of Field section. The Lens Blur filter produces a similar effect with more sophisticated controls and represents the preferred method with newer versions of Photoshop.

Depth of Field. To simulate a reduced depth of field, duplicate the black-and-white image layer (Command/Control+J) and name the new layer "Blur." Apply a Gaussian blur (Filter>Blur>Gaussian Blur) with Radius 25 to the Blur layer, then reduce the opacity of this layer to 50%. This creates the same effect as Soft Focus. Now areas with sharp focus need to be defined. Use one of the selection tools, such as the Magic Wand or Color Range, to make a selection of the areas that are to remain sharp, then inverse the selection (Select>Inverse). With the Blur layer highlighted, click on the Add Layer Mask icon at the bottom of the Layers palette to convert the selection into a layer mask. If the mask needs to be refined, select the Brush tool (B, Shift+B) and paint with black over the areas of the image you want to keep in focus. To lessen the effect of each brush stroke, decrease the opacity of the brush in the Brush Options bar (not the Layers palette, which would also decrease the opacity of the global blur effect). If the focus is sharpened over an area that should be blurred, go back and paint over the area with white or gray.

If the edges of the object to be kept in focus appear smudged by the blur effect, this can be avoided by making a selection of the object before applying the blur. With the selection active, press Shift+Command/Control+J to cut the selected area from this layer and paste it into a new

layer (Layer via Cut). Now apply the Gaussian Blur filter to the Blur layer. The selected object, including its edges, remains sharp, surrounded by a blurred background. The integrity of this image depends upon three layers: the Blur layer, the selected area above, and the black-and-white image layer below. If desired, these layers can be merged after making another copy of the original black-and-white image layer so it is not incorporated into the merged layer. The configuration of the Layers palette depicting the steps described in this section is shown in figure 6-16.

With any blur effect in Photoshop, film grain or digital camera sensor noise is also blurred. Since this differs from the appearance of a blur produced during image exposure, the Photoshop image may appear unnatural. This is easily remedied by judiciously applying the digital equivalent of grain, which is noise. In general, this noise should be applied only to the blurred areas, since the appearance of grain in the sharp areas has not changed. A separate layer for grain can be added by selecting the Blur layer and creating a new layer above it in Overlay blending mode filled with 50% gray. If the Blur layer has a mask that protects the sharp area of the image (as opposed to the sharp area being cut and pasted to another layer), press Command/Control and click on the layer mask to load it as a selection. Highlight the new layer and click on the Add Layer Mask icon to place the same mask on the new layer, then click on the layer thumbnail (not the mask). Now the new layer is ready to receive grain. Go to Filter>Noise> Add Noise. Start with an amount of 1 to 2% with Gaussian distribution and Monochromatic color and, while viewing the image at 100% (Option/Alt+ Command/Control+0 [zero]), adjust the amount of noise until the digital grain in the blurred areas matches the film grain or digital noise in the non-blurred areas. The columbine in figure 6-17 shows how the petals remain sharp after blurring the background using this method.

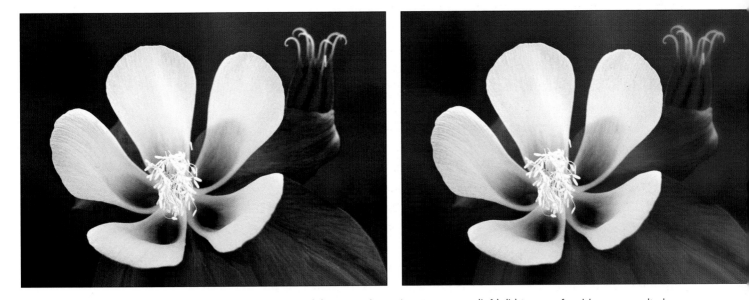

FIGURES 6-17A AND B. LIMITED DEPTH-OF-FIELD, COLUMBINE. (a) Image after B/W Conversion (left). (b) Image after blur was applied as described in text (right).

Lens Blur. Beginning with Photoshop CS, Adobe added Lens Blur, a sophisticated filter to simulate the characteristics of image blur created by a lens. Not only can the blur be applied to any region, but it can also be applied along a gradient so the degree of blurring varies as a function of the distance from the center of interest. This filter can even reproduce the effect of the iris shape of the selected lens, including its Radius, Blade Curvature, and Rotation. The key to using this tool is to define the placement of the blur using either a layer mask or an alpha channel known as a depth mask. Although this may sound complicated, the process is relatively straightforward.

To use this filter to create a blur effect, duplicate the black-and-white image layer and name it "Lens Blur." Next create a selection encompassing the center of interest and add a mask to the Lens Blur layer (fig. 6-18). With the Lens Blur layer image (not the mask) selected, go to Filter>Blur> Lens Blur and select Layer Mask as the source of the depth map (fig. 6-19). If the subject is blurred, click on the subject or click the Invert button. Select a lens iris shape, such as hexagonal, and move the Blade Curvature slider if you want to smooth the edges of the iris. A Threshold can be set for Specular Highlights to specify a value above which all pixels are treated as specular highlights. The brightness of these highlights can be adjusted with the Brightness slider. To replace film grain or digital camera noise removed from the image when it was blurred, adjust the settings in the Noise section. Viewing the image at 100% in the dialog box, select an Amount that appears natural. Gaussian distribution more closely matches film grain. Choose Monochromatic so the noise does not change colors in the image. To see the effect of the filter, delete the Layer Mask after the Lens Blur has been applied. Applying this filter to the same image as in the Depth of Field section (fig. 6-17a) resulted in the blur effect seen in figure 6-20.

FIGURE 6-18. LAYERS PALETTE, LENS BLUR VIA MASK. The black-and-white image layer was duplicated, then a mask was added to the duplicate layer. The white area of the mask will protect image pixels from blurring by the Lens Blur filter. To see the effect of applying the filter, the mask must be hidden or removed.

FIGURE 6-19. LENS BLUR DIALOG BOX. The source of the depth map is the Layer Mask rather than an alpha channel.

FIGURE 6-20. LENS BLUR FILTER, LAYER MASK. The result of blurring the image in figure 6-17a using the Lens Blur filter is more subtle than the result using the Gaussian blur technique.

This effect is similar to that achieved in the Depth of Field section using the Gaussian Blur filter, except that with the Gaussian blur technique the lens characteristics cannot be reproduced. Although the Lens Blur effect is much more subtle than was demonstrated above with Gaussian blur, this filter can be applied multiple times if needed to produce more blur (if this was the last filter applied, press Command/Control+F as many times as you want to apply it).

An alternative method of applying the Lens Blur filter to this type of image is to use an alpha channel rather than a layer mask as the depth mask. Go to the Channels palette and click on the Create New Channel icon at the bottom of the palette to create a new channel, called Alpha 1. Click the empty box to the left of the image thumbnail on the RGB channel so the image is visible through a rubicon (the default color) mask. With the alpha channel selected, choose a white brush (B, Shift+B) with soft edges and paint over the areas to remain sharp (non-blurred). When the mask is complete, select the composite RGB channel so subsequent changes apply to all channels, then go to the Layers palette and select the Lens Blur layer. Proceed as above to apply the Lens Blur filter, except choose Alpha 1 rather than Layer Mask as the source of the depth map.

The blur produced by this filter is even more impressive when applied through a depth mask formed from a gradient. This type of depth mask will work appropriately only if objects in the image become closer as one moves from one side of the image to the other. Duplicate the black-and-white image layer (Command/Control+J) and name it "Lens Blur." Go to the Channels palette and click on the Create New Channel icon. Then click on the empty square to the left of the RGB channel thumbnail so you can see the image. The image should appear with a color overlay—if it does not, make sure the new alpha channel is highlighted. Now open the Gradient tool (G, Shift+G) and, from the Options bar, select Linear Gradient. Type D to set the default foreground and background colors, then drag a Foreground-to-Background gradient from distal elements at one side of the image to near elements at the opposite side. To make the direction of the gradient absolutely vertical or horizontal, press the Shift key as you drag from top-to-bottom or side-to-side, respectively. This gradient can be applied along any axis to match the subject and orientation of the image. This creates a black-to-white gradient that represents the depth mask through which the Lens Blur filter will be applied. If necessary, adjust the gradient so that objects to be in focus are in the white portion of the gradient and objects to be completely out of focus are in the black (masked) portion. In figure 6-21, the gradient was positioned so that the white portion was over the right side of the image and the black portion (appearing as a rubicon mask in the figure) was over the left foreground flower. After completing the gradient, select the RGB channel so the filter will be applied to all channels.

FIGURE 6-21. LENS BLUR, ALPHA CHANNEL. Depth mask created by applying black-to-white gradient from left to right determines which areas will be blurred. The red portion of the image represents a mask (not the actual image color) over the area to be blurred. For images with blur applied over a longer distance, the gradient will not have such an abrupt boundary.

Now open the Lens Blur filter dialog box (Filter>Blur>Lens Blur), shown in figure 6-22. For Depth Map, choose as source Alpha 1, the channel containing the newly created gradient. To set the Blur Focal Distance, click on the image in the dialog box to specify the portion of the image that should be in focus. For the image of the flowers, it is the flower on the right, which has a Blur Focal Distance of 255 because the gradient was placed in such a way that the flower was completely in the white zone. The preview image can be enlarged if desired by pressing Command/Control and hitting the "+" key (more than once if needed) to facilitate precise placement of the focal point. Areas of the image at other positions along the gradient will now appear progressively more out of focus, depending upon the characteristics of the gradient. Adjust the lens settings, noise, and other options as described previously. Applying the Lens Blur filter twice to the image shown in figure 6-23a produced a relatively subtle blur of the foreground flower, as seen in figure 6-23b.

FIGURE 6-22. LENS BLUR DIALOG BOX. The source of the depth map is the Alpha 1 channel, which represents the mask shown in figure 6-21.

a

b

FIGURES 6-23A AND B. LENS BLUR, DEPTH MASK. (a) The black-and-white image before applying the lens blur. The flowers in the background were blurred by the camera lens and do not require any additional blur. (b) Image after blurring the flower in the left foreground. The Lens Blur filter was applied twice with identical settings to create this image.

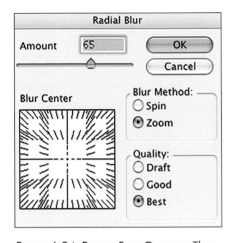

FIGURE 6-24. RADIAL BLUR OPTIONS. These settings were applied to the image in figure 6-26.

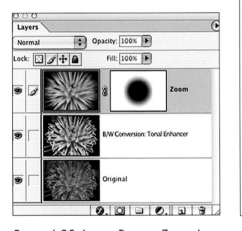

FIGURE 6-25. LAYERS PALETTE, ZOOM LENS EFFECT. The black-and-white image layer was duplicated, then the Radial Blur filter with settings as shown in figure 6-24 was applied. To prevent the blur from affecting the center of the image, a radial gradient was applied to the mask for the Zoom layer.

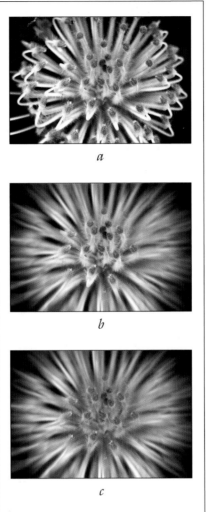

FIGURES 6-26A AND B. ZOOM LENS EFFECT. (a) Black-and-white image after conversion from color. (b) Radial blur with central area masked by radial gradient. (c) Radial blur with color image showing through the masked area.

Zoom Lens Blur. Another photographic technique to draw attention to a center of interest is to use a zoom lens and change the focal length during a long exposure. Only the subject appears focused, surrounded by divergent elements radiating outward. To simulate this effect in Photoshop, add a duplicate black-and-white image layer named "Zoom" and go to Filter>Blur> Radial Blur. Choose the Zoom blur method and start with an Amount near 65 (fig. 6-24). Drag the Blur Center to the desired origin of the blur. Select either Good or Best Quality and click OK. If the amount of blurring is excessive, go to Edit> Fade Radial Blur and decrease the opacity. Ignore the appearance of the blur around the subject. Now click the Add Layer Mask icon at the bottom of the Layers palette to add a mask to the Zoom layer (fig. 6-25). With this mask selected, choose the Gradient tool (G, Shift+G) and select Radial Gradient from the Options bar. Choose the Black, White gradient from the Gradient Editor (accessed by clicking on the gradient sample on the Options bar) with Normal mode and 100% opacity. Place the cursor at the center of the subject and drag outward, releasing the mouse button at the position where you want the full zoom effect to begin. Press the backward slash key ("\") to see a mask of the area affected by the gradient; press it again to hide the mask. Redraw the gradient if needed to modify its origin and radius. To increase the central area of focus, use the Gradient Editor to move the left (Black) Color Stop toward the right to a location around 20 to 40%. The result of applying the Radial Blur filter to a Protea is illustrated in figure 6-26. Note that since the layer mask on the Zoom layer hides the central part of the image, the sharp portion of the image is derived from the black-and-white image layer below. By hiding this layer and making the original color layer visible, an interesting colorizing effect can be achieved.

☐ LIGHTING EFFECTS

A tool I particularly like to use for highlighting features in an image is the Lighting Effects filter. Included among the somewhat mysteriously named Render filters, the Lighting Effects filter offers numerous parameters for controlling lighting. After duplicating the black-and-white image layer, open the Lighting Effects dialog box (Filter>Render>Lighting Effects). I suggest starting with the Soft Omni Style and Omni Light Type, although you will probably want to experiment with different styles and types of lighting (fig. 6-27). Click on the Preview option under the preview window in the dialog box. Within the preview window, a small white spot represents the light source. Drag it over the object to be highlighted and adjust the radius of the illuminated area if necessary, using the handles on the circle surrounding the light source. Select the Properties of the light, including Gloss (start with 100, representing Shiny), Material (start with 100, representing Metallic), Exposure (experiment, but you may want to underexpose), and Ambience (representing the ambient light). Specify the Intensity, starting with a value of 50 or less, and a color other than white if desired. The meaning of some of these terms is not intuitive. For example, Metallic reflects the color of the object, whereas Plastic reflects the color of the light. An Ambience value of +100 eliminates the ambient light source; a value of –100 eliminates the light source. The color of the ambient light can be changed by clicking on

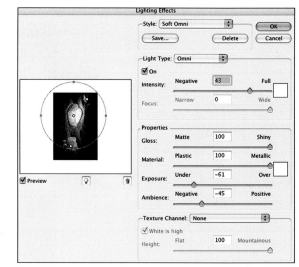

FIGURE 6-27. LIGHTING EFFECTS. The preview image shows the position of three lighting sources. The middle one is selected, showing its radius and characteristics.

a *b*

FIGURES 6-28A AND B. LIGHTING EFFECTS. (a) The black-and-white image after conversion from color. (b) The image after applying the Lighting Effects filter to focus attention on the head of Buddha.

the color box to the right of the Material slider. To highlight an additional element in an image with an identical light, press Option/Alt and drag the light within the preview window to the desired location. To add a light with different characteristics, drag from the lightbulb icon under the preview window to the desired spot in the image and specify the parameters for that light. The power of this filter is amazing. Consider saving settings that give a pleasing effect for use on other images. Applying the Lighting Effects filter with the settings depicted in figure 6-27 to the black-and-white image shown in figure 6-28a yielded a more powerful image by focusing attention on key elements. The dialog box shows the settings I used for the central light, but there are also two other light sources of varying Intensity in the image. I also lightened and darkened selected elements to obtain the final image in figure 6-28b.

☐ ARTISTIC EFFECTS

Filters included with Photoshop or derived from third parties can be utilized to create diverse artistic effects. Some of these seem especially appropriate for black-and-white images.

Graphic Pen. The appearance of a graphic pen can be simulated using the Graphic Pen filter (Filter>Sketch>Graphic Pen) on a duplicate of the image layer. The resultant image will consist of the foreground and background colors, with pen strokes in the foreground color. For a black graphic pen appearance, type D to set the foreground color to black. This filter can be used with either a color or black-and-white image. In my experience,

FIGURE 6-29. GRAPHIC PEN OPTIONS. These settings were used to create the graphic pen effect in figure 6-30.

FIGURE 6-30. GRAPHIC PEN FILTER. A simulation of a graphic pen was applied to the color image of the poppy to create this rendering.

the results seem better with a color image. Applying this filter with the settings depicted in figure 6-29 to a color image of a poppy yielded the drawing effect shown in figure 6-30. If the image does not look like a pen drawing, add a mask to hide the duplicate layer (press Option/Alt then click on the Add Layer Mask icon). Gradually reveal the image by painting on the layer mask with short strokes using a soft white brush with decreased opacity. This is an occasion to use one of the funny-looking brushes located in the Brushes palette below the round ones. If desired, the opacity of the image layer can be decreased to blend it with the underlying color image.

Etching. Several filters in Photoshop offer methods to highlight the edges of objects. Among these, I have created the most striking images using the Find Edges filter (Filter>Stylize>Find Edges). This filter outlines the edges of an image with dark lines against a white background. However, I usually prefer to invert the filtered image so the edges are outlined in white against a black background.

Starting with a color or black-and-white image, press Command/Control+J to duplicate the image layer. Now apply the Find Edges filter to the duplicate layer. If the filter was applied to a color image, convert the image to black and white. One way to do this while leaving the Find Edges layer intact is to add decolorizing adjustment layers above the Find Edges layer. For a more dramatic effect, the Find Edges layer can be duplicated and the blending mode of the new layer changed to Overlay. Then this layer can also be duplicated and the blending mode changed to Multiply. Now the opacities of the Find Edges layers can be adjusted to achieve the desired result. A Curves or Levels adjustment layer can be added to accentuate the white edges. This is the approach I followed with the juniper image in figure 6-31. In addition, I removed distracting white pixels from the background.

FIGURES 6-31A AND B. ETCHING EFFECT. (a) Original Velvia image, Canyonlands Juniper (left). (b) Etching effect produced using the Find Edges filter as described in the above text (right).

Solarization. The nik Color Efex Pro 2 filters produce a number of effects, including several that can be particularly striking with black-and-white images. One filter, known as Solarization BW, is designed to emulate the Sabatier (Solarization) darkroom process, during which images that are being developed are exposed to light again, leading to a reversal of color values. This filter can be used with either color or black-and-white images to create dramatic black-and-white effects (fig. 6-32).

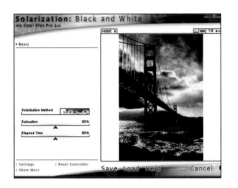

FIGURES 6-32A AND B. NIK COLOR EFEX PRO 2: SOLARIZATION BW FILTER. (a) Dialog Box (above). (b) Application of Solarization filter to black-and-white conversion of the Golden Gate Bridge (right).

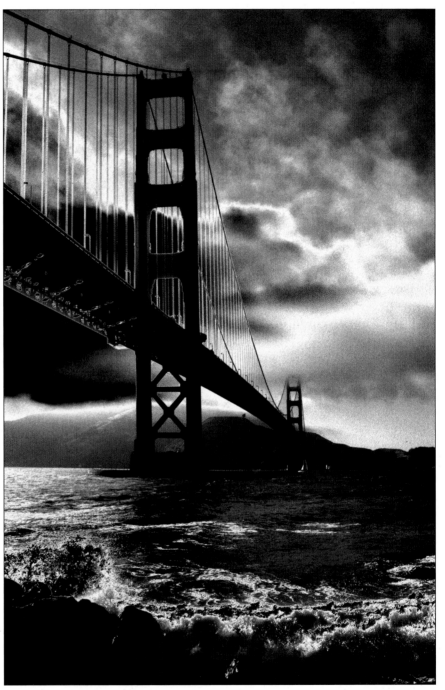

☐ FRAMING EFFECTS

Modifying the edge of an image with tools available in Photoshop or supplied by third-party software makers can produce a variety of edge or framing effects. One of the more popular among these is a vignette effect.

Vignette. A vignette is an artistic technique to frame a subject. Several different approaches can be used, but I will describe one that protects the image pixels. Select the Elliptical Marquee tool (M, Shift+M) and draw an oval selection around the area of the image you want to keep, dragging the cursor while holding the Spacebar to reposition the selection if needed. Type Q to enter Quick Mask mode, which will reveal the elliptical selection as a mask with sharp edges. Type Command/Control+I to invert the mask so it covers the portion of the image to be eliminated from view. To soften the edges of the selection, go to Filter>Blur>Gaussian Blur and select a Radius setting that gives the desired effect. Make sure the Preview button

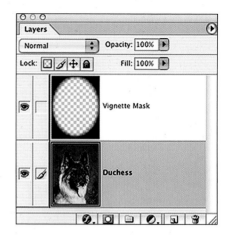

FIGURE 6-33. LAYERS PALETTE, VIGNETTE. This approach creates a vignette without altering or deleting image pixels.

is checked so you can observe the amount of the blur. Type Q again to exit Quick Mask mode and return to the selection. Click on the Add a New Layer icon at the bottom of the Layers palette to add a layer above the image layer (fig. 6-33). Press D to set the foreground color to black. Then press Option/Alt+Delete/Backspace to fill the selected area with black. Voilá, a vignette (see fig. 6-34)! The original image is still intact, but some of it is hiding. With this approach, the color and contours of the vignette can be changed at any time, in contrast to methods that delete pixels to create the vignette.

FIGURE 6-34. VIGNETTE. Duchess.

The Print

After the final digital darkroom adjustments have been applied to the image, save it as the master black-and-white image file (do not overwrite a master color image file). Duplicate this image file (Image>Duplicate), then follow the steps in this chapter to perform final image adjustments and customize the file for a specific print size, printer, and paper.

■ PERFORM FINAL IMAGE ADJUSTMENTS

Burn the Edges. Ansel Adams described the phenomenon whereby mounting an image on a white board tends to produce a faint "flare" along the edges. To compensate for this effect and direct the viewer's attention into the image, he suggested darkening the edges of the image a small amount, a technique known as edge burning. Indeed, he felt that nearly all photographs require some burning of the edges. He also emphasized that the effect should be subtle, such that the viewer is not conscious of it.

ANSEL ADAMS DESCRIBED THE PHENOMENON WHEREBY MOUNTING AN IMAGE ON A WHITE BOARD TENDS TO PRODUCE A FAINT "FLARE" ALONG THE EDGES.

For an 8 x 10-inch print, he recommended burning the outer 2 inches but also stated that the total amount of edge burning should seldom exceed 5 to 10% of the image.

Applying an edge burn is equally important in the digital darkroom. To add the digital equivalent of an edge burn to the image, choose the Elliptical Marquee tool (M, Shift+M) or the Lasso tool and make a selection that encompasses all but the edges of the image. Type Q to enter Quick Mask mode, then go to Filter>Blur>Gaussian Blur and choose a large radius to soften the edge of the mask. Type Command/Control+I to invert the mask. Type Q again to exit Quick Mask mode and return to the selection, now feathered by the blur. Create a new Curves adjustment layer at the top of the Layers palette. The active selection is now incorporated into the mask for that layer. Double-click on the Curves adjustment layer thumbnail to open the Curves dialog box, then pull the curve down to darken the edges of the image. To facilitate subsequent adjustment of the

burn, make the edges a little darker than you think they should be, then adjust the opacity of the layer to set the final burn.

Resize the Image. Flatten the duplicate image (Layer>Flatten Image) to reduce all the active layers to a single layer, discarding the hidden layers. Select Image>Image Size from the menu bar. For inkjet printers, enter a resolution ranging from 240 to 360 pixels/inch in the resolution box (fig. 7-1). For LightJet printers, enter a resolution of 80 or 120 pixels/cm or 200 or 300 pixels/inch, depending upon the printer model. Verify that the Resample Image box is checked, then specify the method of image resampling. If increasing the file size, enter Bicubic Smoother, if available, or Bicubic. If downsizing the file, use Bicubic Sharper or Bicubic. Make sure Constrain Proportions is checked, and enter the longest dimension of the image to be printed (not counting any border). Press OK. If the image is in 16-bits/channel mode, convert it to 8-bits/channel mode (Image>Mode>8 Bits/Channel).

Enhance Local Contrast. In this penultimate step to prepare the image for printing, the Unsharp Mask filter (described in more detail below) can be used to enhance the highlights and shadows in the small details to increase local contrast. Duplicate the image layer (Command/Control+J), then go to Filter>Sharpen>Unsharp Mask. Viewing the image as you adjust the settings in the dialog box, start with settings of: Amount 15 to 20%, Radius 50 pixels, and Threshold 0 (fig. 7-2). To increase the effect, increase the Amount up to around 50%. To decrease the strength of the effect or modify its character, go to Edit>Fade Unsharp Mask and reduce the opacity or change the blending mode of the filter.

Sharpen the Image. Several alternative methods increase the apparent sharpness of an image by enhancing the difference in contrast between adjacent pixels (light pixels are lightened and dark pixels darkened). Regardless of the technique chosen, final sharpening should only be performed after completion of all other image processing steps, including resizing the file size to the desired resolution and dimensions of the print. With each of these methods, the image should be viewed at 100% (Command/Control+Option/Alt+0 [zero]) when assessing the amount of sharpening so that each pixel on the monitor equals one image pixel.

Unsharp Mask. The term "unsharp mask" is derived from the traditional darkroom technique of making an image look sharper using an unsharp mask, a blurred contact negative of the image. The contrast mask is aligned with the image, and photographic paper is exposed by a light source shining through both the mask and original image, creating a print that appears sharper due to enhancement of the edges.

In Photoshop, a similar effect can be achieved using the Unsharp Mask (USM) filter (Filter>Sharpen>Unsharp Mask). The USM dialog box offers three controls: Amount, Radius, and Threshold (fig. 7-3). The Amount determines the strength of the filter, measured by the contrast increase that will occur as a percentage of the original difference in grayscale values

FIGURE 7-1. IMAGE SIZE DIALOG BOX.

FIGURE 7-2. UNSHARP MASK FILTER. Settings with a low amount and high radius may be used to enhance local contrast.

FIGURE 7-3. UNSHARP MASK FILTER. Settings with a higher amount and low radius are used to sharpen the image.

between adjacent pixels. A setting of 100% doubles the perceived edge contrast. Settings for a high-resolution print often range from 100–200%, sometimes higher. The Radius specifies the distance, in pixels, over which USM will be applied. If the Radius is set too high, image detail will be lost. One approach is to divide the file output resolution by 200 to determine the Radius; typical Radius settings are 1–2 pixels. The Threshold determines how different a pixel must be from surrounding pixels before it is sharpened. Higher values decrease the sharpening in low contrast and flat tonal areas of an image. A threshold of 0 sharpens everything, which is not necessarily desirable. The presence of obvious halos along edges in an image suggests it has been overly sharpened.

Sharpen Edges. A variant of USM, Sharpen Edges first creates a mask of the image edges and then applies USM through that mask to limit the areas sharpened. The advantage of this technique is that sharpening can be applied selectively. In particular, areas of uniform color such as the sky can be eliminated from the USM; in such areas, sharpening is not needed and has the generally adverse effect of enhancing the visibility of film grain or digital noise.

To apply this technique, duplicate the image layer by pressing Command/Control+J or dragging the layer down to the Create a New Layer icon. Name this new layer "Sharpen." Now go to the Channels palette and select the channel with the most contrast between the areas to be sharpened. Duplicate this channel by dragging it down to the Create New Channel icon at the bottom of the Channels palette. With this new channel selected, choose Filter>Stylize>Find Edges. Invert the channel by pressing Command/Control+I or Image>Adjustments>Invert. Then select Filter>Noise>Median to emphasize the edge lines and enter a Radius value of 1 to 3 pixels (fig. 7-4). Add to the selection using Filter>Other> Maximum with a Radius of 4 to 5 pixels (fig. 7-5). To soften the effect, add a Gaussian blur (Filter>Blur>Gaussian Blur) with Radius of 4 to 5 pixels (fig. 7-6). Although the radius values for the Maximum and Gaussian Blur filters are not absolute, they should be equal. Press Command/Control+L

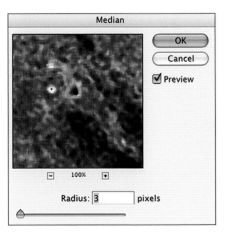

FIGURE 7-4. MEDIAN NOISE FILTER.

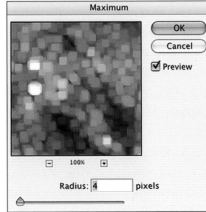

FIGURE 7-5. MAXIMUM FILTER.

FIGURE 7-6. GAUSSIAN BLUR FILTER.

FIGURE 7-7. LAYERS PALETTE, EDGE SHARPEN.
Sharpening is applied through the Edges
Mask on the Sharpen layer.

FIGURE 7-8. HIGH PASS FILTER.

to adjust the channel using Levels. Move the sliders until the areas that should be sharpened are light and those that should not be sharpened are dark. This channel now represents the sharpen edges mask through which sharpening will be applied. Load the channel as a selection by Command/Control+clicking on the channel or pressing Command/Control+Option/Alt+4. Select the RGB composite view in the Channels palette. Return to the Layers palette and add a layer mask to the sharpen layer by clicking the Add Layer Mask icon at the bottom of the Layers palette. The sharpen edges mask will now be converted from a selection into the mask for that layer (fig. 7-7). Click on the image (not the mask) on the Sharpen layer, then select Filter>Sharpen>Unsharp Mask. Viewing the image at 100% (Option/Alt+Command/Control+0 [zero]), select the desired Unsharp Mask values for Amount, Radius, and Threshold, then click OK. The image has now been sharpened through the sharpen edges mask. The Sharpen adjustment layer offers the flexibility to modify the sharpening further by painting on the sharpen edges mask or decreasing the opacity of the layer.

MOVE THE SLIDERS UNTIL THE AREAS THAT SHOULD BE SHARPENED ARE LIGHT AND THOSE THAT SHOULD NOT BE SHARPENED ARE DARK.

High Pass Filter. The High Pass filter can be used as an alternative sharpening tool. This filter maintains edge details within the radius selected but turns other areas neutral gray, suppressing those areas when the blending mode of the layer is set to Overlay, Soft Light, or Hard Light. Inverting the High Pass layer softens the image rather than sharpening it.

To sharpen an image using this filter, duplicate the image layer (Command/Control+J) and name it "High Pass." Change the blending mode of this layer from Normal to Overlay. Viewing the image on your monitor at 100%, select Filter>Other>High Pass and, in the High Pass dialog box, choose a radius of 1 to 6 pixels. Experiment by moving the slider to increase and decrease the radius (fig. 7-8). Small values tend to emphasize small details. As with Unsharp Mask, this technique can produce un-

desirable halos in the image. If the effect is too strong, try Soft Light blending mode or decrease the opacity of the High Pass layer. If the effect is too weak, try Hard Light blending mode or reapply the filter using a different radius value. The sharpening effect can also be increased by duplicating the High Pass layer.

☐ SOFT-PROOF THE IMAGE

Within a color-managed environment, it is possible to use color profiles to soft-proof an image directly on the monitor—to display on-screen a preview of the document's colors as reproduced by a specific printer or in a specific color space. Although the appearance of an image produced by transmitted light (monitor) is inherently different from that produced by reflected light (print), one can judge the appearance of a print with reasonable accuracy. To view the soft proof, select View>Proof Setup>Custom, then from the Proof Setup dialog box select the name of the profile that matches the appropriate printer and paper. The settings to preview a proof from a LightJet printer on matte paper are shown in figure 7-9. The appropriate profile for a commercial printer can usually be downloaded from the company's website. Set Intent to Perceptual (or Relative Intent if this looks better). Select Use Black Point Compensation, which scales the tonal range of the source to that of the destination space. If the soft proof fulfills your visualization of the final print, proceed to the next step. If not, you may want to confirm that your monitor is accurately calibrated and, if it is, do some additional fine-tuning in Photoshop.

FIGURE 7-9. PROOF SETUP, LIGHTJET PRINTER, FUJI CRYSTAL MATTE PAPER.

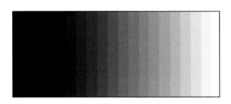

FIGURE 7-10. 5% WEDGE GRADIENT.

☐ CREATE THE PRINT USING A DIGITAL DARKROOM PRINTER

Target Output for a Digital Darkroom Printer. To achieve the maximal tonal range from your printer, consider targeting the image output to match the characteristics of the printer. The concept is simple: make a horizontal gradient that displays gradations from black to white in 5% or smaller increments. To accomplish this, create a new file (Command/Control+N) in RGB mode and set the image size to around 10 x 4 inches. Select the Gradient tool (G, Shift+G) with Black, White gradient, Dither off (since dithering adds a small amount of noise to the gradient, which is not beneficial here). Holding the Shift key to keep the line horizontal, drag the cursor from the left to the right side of the image window to form a horizontal gradient encompassing the tonal range from black to white. Then divide this gradient into 20 different tones, each representing a 5% increase in tonal value from the previous one, by adding a Posterize adjustment layer (click on the half-black/half-white circle icon at the base of the Layers palette and select Posterize from the menu) and entering 20 for the number of Levels. To equalize the distance between the divisions, highlight the

gradient layer and select Image>Adjustments>Equalize. The result is a 5% wedge gradient, as illustrated in figure 7-10. To assess the shadows and highlights more precisely, follow analogous steps to create a horizontal gradient that displays 1% gradations in tonal values from 0 to 15% and from 85% to 100%.

Print the wedge gradient from your printer using the paper you normally use. After allowing time for the print to dry, evaluate it to determine the location of the darkest adjacent tones that can be differentiated. Using a Levels adjustment layer, change the Output Levels shadow number in the Levels dialog box to the value determined from the test print. For exam-

FIGURE 7-11. LEVELS. The Output Levels black point has been changed to value 25.

ple, if you cannot differentiate between the 5% and 10% tones on the printed wedge gradient but can differentiate between the 10% and 15% tones, set the Output Levels shadow slider to the RGB equivalent of 10%, which is 25 (fig. 7-11). However, your printer may be able to differentiate shadows better than this, and you may want to make a 1% gradient for the shadows as described above. Likewise, determine the location of the lightest adjacent tones that can be distinguished and set the Output Levels highlight number to the corresponding value. These shadow and highlight values determine the dynamic range of your printer. Rename the layer to specify the paper and printer to which these adjustments apply. This layer should be visible only when the image is being printed with this printer–paper combination. Although this adjustment will decrease the contrast of

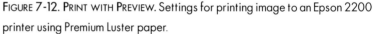

FIGURE 7-12. PRINT WITH PREVIEW. Settings for printing image to an Epson 2200 printer using Premium Luster paper.

the image as displayed on the monitor, the printed image should display the full dynamic range of which the printer–paper combination is capable.

Print the Image. With the Output Levels shadow and highlight values placed at the desired settings, print the image. Select File>Print with Preview. Within the Print with Preview dialog box, check the Show More Options box and select Color Management from the pop-up menu (fig. 7-12). For Source Space, select Document. In the Print Space section, select the profile for printer and paper that will be used. Choose Intent: Perceptual or Relative Colorimetric with Black Point Compensation. The other options will vary somewhat depending upon the operating system and printer, but in the appropriate dialog boxes you should indicate the paper size, type (Media), orientation, printer resolution (usually 1440 dpi), and printer space profile. Set the printable area to maximum and select the centered option. Enable the print preview to confirm correct orientation of the image. If the location of a particular dialog box is not apparent, click on all available buttons and check all pop-up menus. The following dialog

FIGURE 7-13. PRINT DIALOG BOX. Confirm printer setting, then click on Copies & Pages to access additional dialog boxes.

FIGURE 7-14. PRINT SETTINGS. Specify the paper, color ink, and print quality 1440 dpi.

FIGURE 7-15. COLOR MANAGEMENT. Select No Color Adjustment.

boxes apply to the Epson Stylus Photo 2200 printer using Epson Premium Luster Paper. Detailed steps are included because incorrect printer settings represent a common cause of poor digital darkroom output.

From the Print with Preview dialog box, click on the Print button to access the Print dialog box. In the Print dialog box, confirm that the correct printer is listed. Click on Copies & Pages to access a menu that lists two important options that need to be configured: Print Settings and Color Management (fig. 7-13). Choose Print Settings from this menu to open the dialog box shown in figure 7-14. Select Premium Luster Photo Paper (or the appropriate paper), Color ink, and Advanced Settings with Print Quality 1440dpi. Then choose Color Management from the menu and select No Color Adjustment (fig. 7-15). Now click on the Print button to send the image file to the printer.

FIGURE 7-16. PRINT WITH PREVIEW. Settings to simulate LightJet print from Epson 2200 printer using Premium Luster paper.

☐ CREATE THE PRINT USING A COMMERCIAL PRINTER

Print a Proof. When your final print is destined for a commercial printer, producing a proof print represents an important step in obtaining the desired final print. Although the most accurate way to assess the output is to obtain a proof print from the actual printer, the appearance of a print from a commercial printer, such as a LightJet or Chromira photographic printer, can be simulated using an inkjet printer. To do so, configure the Proof Setup as described above, choosing the profile for the commercial printer and paper. To print the proof, go to File>Print with Preview, check the Show More Options box, and choose Color Management from the pop-up menu (fig. 7-16). For Source Space,

select Proof: Proof Setup. This will show the settings entered under Proof Setup. In the Print Space section, select the profile for the printer and paper that will be used to simulate the commercial printer. The settings in figure 7-16 show the configuration to simulate a print from a LightJet printer using an Epson 2200 printer with Epson Premium Luster paper. Choose Intent: Absolute Colorimetric, which simulates the whiteness of the printer paper by slightly tinting the image; the Fuji Crystal Archive paper used for Chromira and LightJet photographic prints actually appears slightly blue. The Print Settings should be the same as shown in figure 7-14. Turn off any color adjustments imposed by the printer. Make the proof print, giving the ink sufficient time to dry before evaluating it.

Prepare the Image File for the Printer. Commercial laboratories output black-and-white prints using LightJet or Chromira printers, the Epson 9600 printer with UltraChrome inks, and the Piezography printer. When submitting a digital file to a commercial laboratory, it is important to determine the exact requirements of that lab for printing the image with a particular printer on a specific paper. Such information is typically present on the company's website, but direct communication is sometimes necessary to clarify specific issues. Special pricing may be available if the images have been preflighted prior to submission.

Before I send a digital file for a LightJet print, I edit the file in Photoshop to place a white border around the image (Image>Canvas Size), stroke the outer border of the image (Select>All, Edit>Stroke, 3 to 4 pixels, black or gray color, and inside location), confirm the proper image orientation (landscape), convert the image to the most recent printer profile from that laboratory for the desired paper (fig. 7-17), and save the file in TIFF format. Then I submit the file to the laboratory on CD or upload it online via FTP.

Preparation of files for other printers is similar. However, files for the Chromira printer do not need to be converted to the printer profile, although they must include the profile for the working space in which the file was created, such as Adobe RGB (1998). Requirements for profiling image files for the Epson 9600 printer differ between laboratories; contact the company for current information. Files for the Piezography printer must be converted to Grayscale (Image>Mode>Grayscale) before they are submitted.

FIGURE 7-17. CONVERT TO PROFILE. When preparing an image file for a commercial printer, apply the appropriate profile and specify the Adobe conversion engine (ACE) with Perceptual Intent and Dither.

Image Gallery

FIGURE 8-1. SUNSET ARCH. Original medium: Velvia transparency film. Technique: nik B/W Conversion, Tonal Enhancer.

The previous chapters describe the process of making black-and-white prints. This chapter presents black-and-white and toned images created from color transparencies using these techniques. A brief description of the methods applied accompanies each image, but—as in a gallery—the primary purpose of this chapter is to showcase the images, not the techniques.

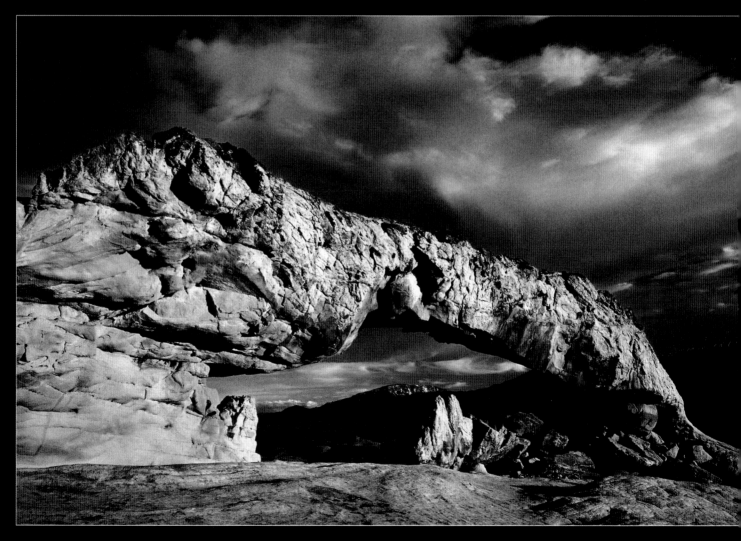

FIGURE 8-2 (RIGHT). INDIAN PAINT-BRUSH. Original medium: Velvia transparency film. Technique: Multilayer BW conversion.

FIGURE 8-3 (BOTTOM). LUMINOUS LILIES. Original medium: Velvia transparency film. Technique: nik Saturation to Brightness filter and B/W Conversion, Tonal Enhancer.

FIGURE 8-4 (ABOVE). ANCIENT OAKS. Original medium: Velvia transparency film. Technique: Channel Mixer BW conversion and Gaussian Blur filter.

FIGURE 8-5 (RIGHT). MOONRISE OVER GRAND CANYON. Original medium: Velvia transparency film. Technique: nik Infrared Black and White filter applied directly to color image.

FIGURE 8-6 (ABOVE). HORSESHOE BEND. Original medium: Velvia transparency film. Technique: nik B/W Conversion, Tonal Enhancer.

FIGURE 8-7 (LEFT). EARTH SPIRIT RISING. Original medium: Velvia transparency film. Technique: Duotone, Black and Pantone® Warm Gray 8 CVC.

FIGURE 8-8 (FACING PAGE). SANDSTONE SWIRL. Original medium: Velvia transparency film. Technique: nik B/W Conversion, Tonal Enhancer.

FIGURE 8-9. SIERRA WATERFALL. Original Medium: Velvia transparency film. Technique: Duotone (quadtone).

FIGURE 8-10. THE SMOKE THAT THUNDERS. Original medium: Velvia transparency film. Technique: Channels as layers BW conversion.

FIGURE 8-11 (FACING PAGE). DUET. Original medium: Velvia transparency film. Technique: nik B/W Conversion, Tonal Enhancer.

FIGURE 8-12 (RIGHT). POHONO FALL. Original medium: Velvia transparency film. Technique: Multilayer BW conversion.

FIGURE 8-13 (FACING PAGE). ST. FRANCIS, RANCHOS DE TAOS. Original medium: Velvia transparency film. Technique: Multistep BW Conversion.

FIGURE 8-14 (RIGHT). BIG SUR. Original medium: Provia transparency film. Technique: nik B/W Conversion.

A Final Thought

In response to the frequent query, "What would Ansel Adams say?" regarding digital image capture and printing, I think the answer is implicit in his own words, penned only months before the debut of the IBM PC in 1981:

> I eagerly await new concepts and processes. I believe that the electronic image will be the next major advance. Such systems will have their own inherent and inescapable structural characteristics, and the artist and functional practitioner will again strive to comprehend and control them.[1]

New concepts and processes have indeed made electronic images a reality. Now is the time for us, as artists and functional practitioners, to endeavor to comprehend and control concepts and processes such as those described in this book as we pursue the art of making black-and-white prints in the digital darkroom.

1. *The Negative*, xiii.

Index

THE DIGITAL DARKROOM GUIDE WITH ADOBE® PHOTOSHOP®

Maurice Hamilton

Bring the skills and control of the photographic darkroom to your desktop with this complete manual. $29.95 list, 8½x11, 128p, 140 color images, index, order no. 1775.

PHOTOGRAPHING CHILDREN IN BLACK & WHITE

Helen T. Boursier

Learn the techniques professionals use to capture classic portraits of children (of all ages) in black & white. Discover posing, shooting, lighting, and marketing techniques for black & white portraiture in the studio or on location. $29.95 list, 8½x11, 128p, 100 b&w photos, order no. 1676.

ZONE SYSTEM

Brian Lav

Learn to create perfectly exposed black & white negatives and top-quality prints. With this step-by-step guide, anyone can learn the Zone System and gain complete control of their black & white images! $29.95 list, 8½x11, 128p, 70 b&w photos, order no. 1720.

GROUP PORTRAIT PHOTOGRAPHY HANDBOOK, 2nd Ed.

Bill Hurter

Featuring over 100 images by top photographers, this book offers practical techniques for composing, lighting, and posing group portraits—whether in the studio or on location. $34.95 list, 8½x11, 128p, 120 color photos, order no. 1740.

THE ART OF BLACK & WHITE PORTRAIT PHOTOGRAPHY

Oscar Lozoya

Learn how Oscar Lozoya uses unique sets and engaging poses to create black & white portraits that are infused with drama. Includes lighting strategies, special shooting techniques, and more. $29.95 list, 8½x11, 128p, 100 duotone photos, order no. 1746.

THE BEST OF WEDDING PHOTOGRAPHY, 2nd Ed.

Bill Hurter

Learn how the top wedding photographers in the industry transform special moments into lasting romantic treasures with the posing, lighting, album design, and customer service pointers found in this book. $34.95 list, 8½x11, 128p, 150 color photos, order no. 1747.

THE BEST OF WEDDING PHOTOJOURNALISM

Bill Hurter

Learn how top professionals capture these fleeting moments of laughter, tears, and romance. Features images from over twenty renowned wedding photographers. $29.95 list, 8½x11, 128p, 150 color photos, index, order no. 1774.

THE DIGITAL DARKROOM GUIDE WITH ADOBE® PHOTOSHOP®

Maurice Hamilton

Bring the skills and control of the photographic darkroom to your desktop with this complete manual. $29.95 list, 8½x11, 128p, 140 color images, index, order no. 1775.

COLOR CORRECTION AND ENHANCEMENT WITH ADOBE® PHOTOSHOP®

Michelle Perkins

Master precision color correction and artistic color enhancement techniques for scanned and digital photos. $29.95 list, 8½x11, 128p, 300 color images, index, order no. 1776.

POWER MARKETING FOR WEDDING AND PORTRAIT PHOTOGRAPHERS

Mitche Graf

Set your business apart and create clients for life with this comprehensive guide to achieving your professional goals. $29.95 list, 8½x11, 128p, 100 color images, index, order no. 1788.

BEGINNER'S GUIDE TO ADOBE® PHOTOSHOP® ELEMENTS®

Michelle Perkins

Packed with easy lessons for improving virtually every aspect of your images—from color balance, to creative effects, and more. $29.95 list, 8½x11, 128p, 300 color images, index, order no. 1790.

BEGINNER'S GUIDE TO PHOTOGRAPHIC LIGHTING

Don Marr

Create high-impact photographs of any subject with Marr's simple techniques. From edgy and dynamic to subdued and natural, this book will show you how to get the myriad effects you're after. $29.95 list, 8½x11, 128p, 150 color photos, index, order no. 1785.

POSING FOR PORTRAIT PHOTOGRAPHY

A HEAD-TO-TOE GUIDE

Jeff Smith

Author Jeff Smith teaches surefire techniques for fine-tuning every aspect of the pose for the most flattering results. $29.95 list, 8½x11, 128p, 150 color photos, index, order no. 1786.

PROFESSIONAL MODEL PORTFOLIOS

A STEP-BY-STEP GUIDE FOR PHOTOGRAPHERS

Billy Pegram

Learn how to create dazzling portfolios that will get your clients noticed—and hired! $29.95 list, 8½x11, 128p, 100 color images, index, order no. 1789.

THE PORTRAIT PHOTOGRAPHER'S
GUIDE TO POSING

Bill Hurter

Posing can make or break an image. Now you can get the posing tips and techniques that have propelled the finest portrait photographers in the industry to the top. $29.95 list, 8½x11, 128p, 200 color photos, index, order no. 1779.

MASTER LIGHTING GUIDE

FOR PORTRAIT PHOTOGRAPHERS

Christopher Grey

Efficiently light executive and model portraits, high and low key images, and more. Master traditional lighting styles and use creative modifications that will maximize your results. $29.95 list, 8½x11, 128p, 300 color photos, index, order no. 1778.

DIGITAL INFRARED PHOTOGRAPHY

Patrick Rice

The dramatic look of infrared photography has long made it popular—but with digital it's actually *easy* too! Add digital IR to your repertoire with this comprehensive book. $29.95 list, 8½x11, 128p, 100 b&w and color photos, index, order no. 1792.

THE BEST OF DIGITAL WEDDING PHOTOGRAPHY

Bill Hurter

Explore the groundbreaking images and techniques that are shaping the future of wedding photography. Includes dazzling photos from over 35 top photographers. $29.95 list, 8½x11, 128p, 175 color photos, index, order no. 1793.

INTO YOUR DIGITAL DARKROOM STEP BY STEP

Peter Cope

Make the most of every image—digital or film—with these techniques for photographers. Learn to enhance color, add special effects, and much more. $29.95 list, 8½x11, 128p, 300 color images, index, order no. 1794.

LIGHTING TECHNIQUES FOR
FASHION AND GLAMOUR PHOTOGRAPHY

Stephen A. Dantzig, PsyD.

In fashion and glamour photography, light is the key to producing images with impact. With these techniques, you'll be primed for success! $29.95 list, 8½x11, 128p, over 200 color images, index, order no. 1795.

WEDDING AND PORTRAIT PHOTOGRAPHERS' LEGAL HANDBOOK

N. Phillips and C. Nudo, Esq.

Don't leave yourself exposed! Sample forms and practical discussions help you protect yourself and your business. $29.95 list, 8½x11, 128p, 25 sample forms, index, order no. 1796.

PROFITABLE PORTRAITS

THE PHOTOGRAPHER'S GUIDE TO CREATING PORTRAITS THAT SELL

Jeff Smith

Learn how to design images that are precisely tailored to your clients' tastes—portraits that will practically sell themselves! $29.95 list, 8½x11, 128p, 100 color photos, index, order no. 1797.

PROFESSIONAL TECHNIQUES FOR
BLACK & WHITE DIGITAL PHOTOGRAPHY
Patrick Rice

Digital makes it easier than ever to create black & white images. With these techniques, you'll learn to achieve dazzling results! $29.95 list, 8½x11, 128p, 100 color photos, index, order no. 1798.

THE PRACTICAL GUIDE TO DIGITAL IMAGING
Michelle Perkins

This book takes the mystery (and intimidation!) out of digital imaging. Short, simple lessons make it easy to master all the terms and techniques. $29.95 list, 8½x11, 128p, 150 color images, index, order no. 1799.

DIGITAL LANDSCAPE PHOTOGRAPHY STEP BY STEP
Michelle Perkins

Using a digital camera makes it fun to learn landscape photography. Short, easy lessons ensure rapid learning and success! $17.95 list, 9x9, 112p, 120 color images, index, order no. 1800.

MARKETING & SELLING TECHNIQUES
FOR DIGITAL PORTRAIT PHOTOGRAPHERS
Kathleen Hawkins

Great portraits aren't enough to ensure the success of your business! Learn how to attract clients and boost your sales. $34.95 list, 8½x11, 128p, 150 color photos, index, order no. 1804.

ARTISTIC TECHNIQUES WITH ADOBE® PHOTOSHOP® AND COREL® PAINTER®
Deborah Lynn Ferro

Flex your creative skills and learn how to transform photographs into fine-art masterpieces. Step-by-step techniques make it easy! $34.95 list, 8½x11, 128p, 200 color images, index, order no. 1806.

DIGITAL PHOTOGRAPHY BOOT CAMP
Kevin Kubota

Kevin Kubota's popular workshop is now a book! A down-and-dirty, step-by-step course in building a professional photography workflow and creating digital images that sell! $34.95 list, 8½x11, 128p, 250 color images, index, order no. 1809.

PROFESSIONAL POSING TECHNIQUES FOR WEDDING AND PORTRAIT PHOTOGRAPHERS
Norman Phillips

Master the techniques you need to pose subjects successfully—whether you are working with men, women, children, or groups. $34.95 list, 8½x11, 128p, 260 color photos, index, order no. 1810.

NIGHT AND LOW-LIGHT
TECHNIQUES FOR DIGITAL PHOTOGRAPHY
Peter Cope

With even simple point-and-shoot digital cameras, you can create dazzling nighttime photos. Get started quickly with this step-by-step guide. $34.95 list, 8½x11, 128p, 100 color photos, index, order no. 1814.

MASTER COMPOSITION GUIDE FOR DIGITAL PHOTOGRAPHERS
Ernst Wildi

Composition can truly make or break an image. Master photographer Ernst Wildi shows you how to analyze your scene or subject and produce the best-possible image. $34.95 list, 8½x11, 128p, 150 color photos, index, order no. 1817.